An Economy of Signs

An Economy of Signs

Contemporary Indian Photographs

EDITED BY
Sunil Gupta

Rivers Oram Press
London and Boston

First published in 1990 by
Rivers Oram Press
144 Hemingford Road, London N1 1DE

Published in the USA by
Unwin Hyman Inc
955 Massachusetts Ave
Cambridge, Mass. 02139

Set in Photina and Helvetica
and printed in Great Britain
by Butler & Tanner Ltd
The Selwood Printing Works, Frome, Somerset BA11 1NF
Designed by Lesley Stewart

British Library Cataloguing in Publication Data

An economy of signs: contemporary Indian photographs.
 1. Indian photographs
 I. Gupta, Sunil
 779.0954

ISBN 1 85489 033 6 (cloth)
ISBN 1 85489 031 x (paper)
ISBN 1 85489 034 4 (non-net)

Contents

Acknowledgments

The publishers wish to acknowledge support for this publication from The Photographers' Gallery, London. The work which appears here, much of it specially commissioned by the Gallery, is included in their exhibition *An Economy of Signs: Contemporary Indian Photography*. The exhibition is sponsored by CMC Limited and Kingfisher Strong Lager Beer, and presented with the assistance of Visiting Arts.

Published with financial assistance from the Arts Council of Great Britain.

The limericks are by Amit Jayaram

To my mother and in memory of my father

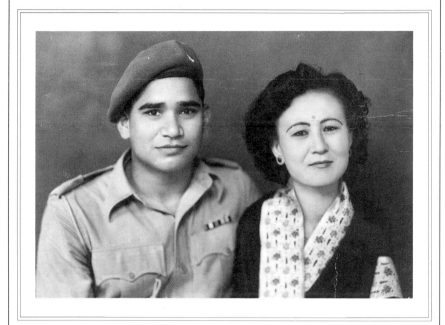

Penny and Shri Ram (1923–88) Photographer unknown, c.1947

If you ever have gone without eating
And taken a jolly good beating
Then democracy's reach
And freedom of speech
And development meetings are fleeting

Preface

Sunil Gupta

*T*he exhibition, *An Economy of Signs*, is the work of eight photographers, who were all born after Independence and who are part of the generation that has now come of age and is busy recreating the modern Indian state. India is a very big country overlaid with many histories and many cultures. It is a minefield of contradictions; an ancient heritage yet in modern terms a very young country.

The title of the exhibition is an allusion to the stories of R.K. Narayan about a mythical South-Indian town Malgudi, a series of novels, each a detailed description of a character in the town, which combine to present a mosaic, a microcosm of Indian society. In this case, 'Economy' is India and 'Signs' are the photographs which act as pointers to decode the myriad complexities and contradictions that make up Indian society today. The conflicts between and within its urban and rural societies, its English-speaking and non-English-speaking citizens, its caste system and its political structures, the demands of its religious and ethnic groupings, its drive to create a national, secular identity and the aspirations of its regions make it possible only to provide 'signs' towards understanding these complexities.

Photography in India today is gaining in popularity, much as it has in the West. Although its high costs had traditionally limited it to those who could afford a very expensive hobby, nowadays it has a very broad-based appeal. Cheaper cameras that are easier to use are now available, as is film stock and access to instant processing and printing. It is common to see Indian tourists photographing their country and families with much the same ease as their European or American counterparts.

Most photographers in India are self-taught, with little or no formal training and when they go overseas to train they tend to go to America rather than to Britain. Perhaps because the funding offered is more generous than in Britain and perhaps it is a reaction to the image of Britain's reduced influence in the world of photography. Meanwhile, an explosion in the

print media in India, soon to be followed by expansion in the electronic media is providing a basis for consistent commercial work. As India is a multilingual country, photography again proves the ability to move across cultural boundaries with greater ease than other forms of communication.

The idea for the exhibition originated in a combination of factors: the growth of Black Arts in Britain, the government-sponsored Festival of India in 1983 and a perceived lack of photography from India in the West – other than that provided by the news media or the travelogue. The initial idea sprang from the Standard Chartered Commonwealth Photography Award.[1] This revealed that there was a great interest in photography in Asia, particularly in the Indian sub-continent, that might provide the basis for the kind of international dialogue that was removed from the salon and the museum: a dialogue based upon experiences of strategies for practices that photographers on both sides could build upon. The polarisation of practices into autonomous and rival cultures was no longer helpful; shared experience of a variety of modes of independent production in different countries each with their own peculiar limitations would be much more helpful as a starting point.

There is still the fundamental problem that international agendas for visual art are being set by mainstream museums and media in the West; official ideologies, uncritical of cultural practices, have been taught to practitioners and curators in other countries. The dominant idea in terms of photography is that it is not seen to exist outside Europe, America and Japan – curiously, since the omitted vast areas of the world have historically provided a ceaseless source of inspiration and subject matter to the West.[2]

I decided to research independent photographers in India to see if there were any and if so, whether there was any common ground. The search for photographers began four years ago when I proposed to *Creative Camera*[3] that they consider publishing a special issue on Indian Photography from India to coincide with India's fortieth Anniversary of Independence in 1987. The magazine idea grew into the possibility of mounting a simultaneous exhibition. The Photographers' Gallery, Britain's best-known international photography gallery, got involved and a much lengthier research process was mapped out which led to a three year development period.

With limited research funds that dictated a restricted choice of locations, an initial trip followed up prior contact by letter, early in 1989. Travel was confined to two cities: Delhi and Bombay, the former the political and the latter, the commercial centre of India. This choice was also determined by the location of the national media in Delhi and Bombay which offers photographers the best commercial opportunities and which demands, as

[1] *Pictures of Everyday Life*, Noelle Goldman and Stuart Hall, Comedia Publishing Group, 1987.

[2] For a detailed discussion of this see my essay 'Northern Media/Southern Lives', *Photography/Politics 2*, eds. Watney, Spence and Holland, Methuen, 1987.

[3] A British magazine servicing the independent photography sector.

such centres in other countries do, that the photographers be close to hand, Fotomedia (Delhi), an independent photography agency, began to co-ordinate the research in India, seek local sponsorship and venues for a possible Indian tour. The process of making contact with independent work was a difficult one as there are no national organisations to serve such photographers' needs. Individuals often knew only of a handful of other individuals, usually in their own region.

By the summer of 1989 a short-list of sixteen photographers was brought down to eight. Although all the short-listed nominees demonstrated technical ability and a range of good project ideas, the final selection was based upon a commitment to an equal mix of women and men, colour and black and white work, and as broad a range of issues as possible. Given the complexity of the subject and the limited resources there was no point in even attempting to embrace all the issues.

Sheba Chhachhi's work stems from her involvement with the Women's Movement and has moved out of a documentation of public events to experimenting with a new strategy for presenting the lives of activist women. Ashim Ghosh has been following 'Sadhus' (ascetics) for some time as an example of a tradition for alternative lifestyle and faith that has stood the test of time. Karan Kapoor, himself an Anglo-Indian, has been photographing this group of people who are caught in the polarity of being Indian and British, a missing people. Amita Prasher has worked on rural development for many years. She combines her interest in women's issues and in the work of a non-governmental organisation into a story about the survival of rural families who must learn to develop their women's skills to adapt to the new economy. Ram Rahman's deceptive 'snapshots' of Delhi are laden with clues about the survival of the city's traditions, the survival of its people and the siting of an enormous struggle to govern the world's largest democratic society.

Sanjeev Saith's interest in mountaineering and precisely framed, colour photography led to this body of work which shows the arrival of modernity to a people largely cut off from the mainstream of Indian society. Little clues abound to demonstrate that slowly, but surely, twentieth century materialism is creeping into these people's lives. Will their prayer flags be enough? Ketaki Sheth's Bombay Portraits reveal the drama in the ordinary lives of a range of Bombay citizens. Where an outsider might juxtapose the shanty town with the highrise, Sheth knowingly selects more intimate moments, where people are characters not caricatures. Sooni Taraporevala belongs to another minority threatened with extinction – Parsis. Her work, rooted in autobiography, reveals her training in the cinema where each frame is composed for its narrative content. Her final image, of a Parsi man in a 'solar topee' looking westward across the bay, suggests both the

dilemma of Parsis who have provided some of the economic muscle which led India towards industrialisation, and who now live captive lives in a city run by the Shiva Sena (a political party aligned with right-wing Hindu fanaticism), and the dilemma of India as it gazes westward both in suspicion and in hope.

Saleem Kidwai writes about the social history of representation in India; who the patrons were, how, until recently, artists remained anonymous and how the visual arts found themselves in a vacuum during the Raj with serious consequences today; and of the dilemma of adopting a foreign tradition of masterworks by named artists. Ram Rahman writes in detail on how these issues have translated into Indian photography with catastrophic results. Without a national policy, without training, hindered by an adherence to nineteenth century values and the cult of a few individual personalities, independent photographers in India need to organise to begin the debates, to demand training, exhibition spaces, specialist publications, develop criticism, create a national archive and finally to make links nationally and internationally.

This exhibition and book would not have happened without help and advice from the following: Noelle Goldman, then at the Commonwealth Institute for her initial enthusiasm, Peter Turner, editor of *Creative Camera*, provided the initial research funds, Sue Davies, director of The Photographers' Gallery, provided the initial list of contacts in India. Alexandra Noble, then at The Photographers' Gallery, for encouragement at the early stages, Martin Caiger-Smith as Exhibitions Organiser at The Photographers' Gallery for his support and advice throughout, and particularly for his judgment in the selection process, Mumtaz Karimjee, organiser of 'Four Indian Women Photographers' at the Horizon Gallery, London 1988, Radhika Singh at Fotomedia for her enthusiasm, knowledge and fund-raising efforts, Brett Rogers at the British Council, Barry Lane at the Arts Council of Great Britain for his support, Amit and Keerti Jayaram who put up with my unannounced arrivals at their home in Delhi, all the photographers in India who sent me material, Elizabeth Fidlon of Rivers Oram who agreed to publish the book at such short notice and finally Stephen Dodd for tolerating Indian photography in his home.

FOREWORD: Indian Art and Artists – myths and realities

Saleem Kidwai

The 1980s was the decade for the celebration of Indian arts (and crafts). Festivals of India were held in the United States of America, the USSR, Japan and in the major nations of western Europe. That these events were a celebration is evident from their being dubbed 'festivals'; they were meant to proclaim the emergence of India, through its achievements in the fields of science and technology, as a modern nation also and to remove the stigma of third-world nation. But the real emphasis of the innumerable exhibitions that formed a part of these 'festivals' was the glorious past of India. Icons and paintings, jewels and brocades, music and dance were used to stress the magnificence of India's past. This seems to have been considered necessary because Indian art was bound to attract the crowds and get extensive media attention which could then be used to drum up jingoistic nationalist pride at home. Social and political comment was buried under the spectacular imagery of Indian miniatures or the magnificence of Chola bronzes. The reality, that the 1980s was the most difficult decade in the history of this independent nation, was diluted.

The cost-benefit ratio of this exercise, in terms of increasing tourism and foreign investment, is yet to be worked out; that is, if the government is willing to spend more money than it already has on these cultural manifestations. But what these festivals definitely did was to reinforce some old myths about India's history and art heritage and to create new ones about the role of Indian artists in contemporary India, most of whom were labelled craftsmen and put on display as if they were themselves objects.

Plurality, one of the most important features of Indian society was acknowledged by the acceptance of the little tradition within the exhibitions of tribal arts and rural 'crafts'. That the greater tradition was stressed was not surprising. But its role and application was exaggerated to the point where it appeared to be almost universal in its applicability. The nature of this greater tradition was mythified and this naturally needed an accompanying mythification of Indian history. This is in keeping with the dominant view of the theoreticians of aesthetics today. The contradictions

inherent in this exposition of Indian art were totally ignored. On the one hand, endless cliches stress the religious, sublime and spiritual nature of Indian art. On the other, no attempt is made to relate this to the position of the creators of this art. Artists in India's history were always relegated to the lowest rungs of the social hierarchy, sometimes even to the position of untouchables. That this contradiction was never examined or explained in the countless and lavish publications that marked the 'festivals' is not surprising. Discussions of Indian art are almost a verbatim paraphrasing of the theories of the ancient and medieval theorists of art and aesthetics in whose attitudes the hierarchic and paternalistic tradition dominates.

That there is a continuity in the art traditions of India from pre-history until the beginnings of colonialism is fairly evident. Elements of pre-historic art are still reflected today. In the murals in village houses and in the arts of the tribals many similarities with Neolithic rock paintings can be found. Naturalism in Indian art can be traced to the 'Harappan Torso', a piece that survives along with terracotta animals and statuettes. Most iconographic and formalistic depictions of later Indian art already prevailed in the imagery on seals from the Indus Valley civilisation five-thousand years ago. This civilisation was spread over nearly half-a-million square miles, including parts of modern-day Afghanistan and Iran. The uniformity of cultural sophistication and of technology, if not its artistic achievement shows an early standardisation of style and aesthetic.

The subsequent high point in the formal art history of India appeared along with the first great empire, that of the Mauryas, and the adoption and aggressive propagation of Buddhism by its ruler, Ashoka, in the fourth and third centuries BC. Iranian influences are evident in Mauryan art and subsequent influences from the North-West continued to flow in with the Greeks, the Parthians, the Scythians and the Kushanas. The Gupta Empire, established in the fourth century AD and surviving until the eighth, saw the re-emergence of Hinduism as the state religion and extensive patronage of the arts – sculpture, painting, architecture and literature.

The rise of Islam also had its impact on India. Culturally the western coast felt the impact much earlier, but it was in the thirteenth century AD, with the establishment of the Muslim dynasties in the Indo-Gangetic plains, that systematic diffusion of new aesthetic ideals and techniques began. These early Muslim dynasties were not very stable politically and in the field of the arts they contributed to architecture and to little else. It was under the Mughals, the migrants from Samarkand to Agra, that the state was again in a position to patronise the arts on a large scale and like the Mauryas, earn the right to be identified with an historical period in art history. What was crucial in this period and needs emphasis is the continuous inter-action of the traditional artistic ideals with newer ones and

the constant expansion of the vocabulary of the artists and the evolution of techniques. From the mid-sixteenth century onwards to the end of the eighteenth century there was hectic artistic activity due to the emergence of this powerful, nearly all-India state. Syncretism in aesthetic values is best exemplified in this period. The traditions established by the Mughal court continued to be followed by the successor states until they fell prey to expanding British colonialism. It is now that a major break in 'artistic tradition' takes place due to the change in the system of patronage and the effects of mercantilism.

The pluralism of Indian society was reinforced by the appearance of indigenous religions like Buddhism and Jainism and the differences within the majority religion itself. These differences could be based on local practices, linguistic groups, sectarian and cult groups and castes and sub-castes. Minorities found it easy to adapt in the liberal atmosphere that this pluralism generated. They were also conditioned by the larger social patterns since they had to co-exist in similar socio-economic conditions. Common value systems naturally evolved. Cultural and religious minorities also made their own impact in terms of their traditions which when not antagonistic to the existing society, were either allowed to co-exist or were absorbed, not completely without trace.

It is alarming that art historians, with the state's backing, continue to derive their inspiration from the discussion of aesthetics of the ancient and medieval period. It is on the basis of these discussions that the definitions and parameters of the great Indian art tradition is based. The problem with this is twofold. First, classical texts mostly date from the Gupta period or the period immediately after. This so-called 'Golden Age' was, it must be remembered, also the period of Brahmanical revival. It is the classical period of Sanskrit literature and this is why most discussions of Indian art succumb to the level of pure semantics. Second, the ideals expounded by these texts are limited to medieval Hindu art and might in some cases include earlier Buddhist examples. Does that mean that the great tradition of Indian art fossilised somewhere after the reign of Harshavardhan (606–647 AD)? This scholarship has to rank as the foremost academic disservice to the cause of Indian art and has very important political implications for contemporary India.

The basic fallacy, which has been so often propounded that it has almost acquired the status of a truism, is that Indian culture and its artistic manifestations originated in philosophical concepts, were religious in idiom

and spiritual in their essential character; that all art was a reflection of metaphysical thought and idealistic values. Naturally, art would in such cases, have little connection with the realities of material existence. Indian art was supposed to be an extension and illustration of religious principles and speculative thought. In such a situation the concern of the artist was to transcend the human condition. The artist is exhorted to search inwards into his soul for truth rather than outwards for a variety of expression. The Indian artist was supposed to 'probe the problems of vision' and the possibility of extending horizons and perceptions. Good art was the product of all sensory perceptions acting together. Those practicing 'Chitra' (painting/sculpture) were supposed to have mastered the arts of music and dance. The artist is actually the transmitter of divine ideals. The act of creation is thus a rite possessing magical powers. And in the end everything is a matter of semantics. What is the difference between 'Shilpa' and 'Kala' (art/craft); what is the real meaning of 'Rasa', etc?

Art is the most tangible and vivid manifestation of the built-in creativity of a society and also of its values and tensions. The visual arts are the least abstract of Indian arts; they are the most expressive exposure of the psyche of society. Art does concern the spirituality of society, but it also reflects the experiences of the people as much as their cultural consciousness. It is the expression of the most significant experience in the life of the artist. It is also the artist's means of livelihood. One therefore has to examine the dialectics of the relationship between the theory and practice of the art.

Indian art need not only be understood in a mystical and esoteric sense. There is more to it than the transcendental meaning ascribed to it. It is essentially naturalistic and humanistic. The enormous output of art and the immense range of objects which received the artists' attention and energy clearly indicate that aesthetics were a part of the day-to-day life of the individual and not just the concern of the theoretician, philosopher and priest.

This is not to deny the role of religious inspiration. Religion was crucial to all ancient and medieval societies. Social conditioning would naturally lead to the predominance of the religious idiom in an artist's vocabulary. The patronage of artists often came from the temples, priests and kings who wanted to propagate a particular cult. The predominance of religiously inspired art does not necessarily mean that this was the only form of art. By its very nature, religious art had more chances of being preserved by successive generations. Secular art objects would tend to perish far more easily but the continuing traditions of non-religious art are the best proofs that religion was not the only concern and inspiration of the Indian artist. The pantheistic nature of Hinduism also made it easy to confuse divine and human images.

Indian art did not just develop out of the religion and spirituality of the people of the great empires. It was as much fed on the experiences of the folk and tribal people who were always marginalised in such empires. Real life instead inspired religion; gods appeared dressed as medieval kings and temple imagery was modelled after that of the court.

A major problem with this approach has been that important questions have gone unasked. No-one talks of the difficulties that were inherent in tradition or the process of reaction to foreign aesthetic stimuli. Was the artist aware of the infinite speculation inherent in these aesthetic theories and practice his or her art with them in mind? Did a sculptor spend a lifetime mastering music and dance or did he or she practice the skills as required for the craft and trust his/her senses for the creation of the image he or she envisaged. The freezing of movement which encapsulates the essence of action, the freezing of time which stresses its eternity, the freezing of form which underlines the universality of the shape were not the result of the artist being educated in the theories of 'Natya' (dance/drama). In fact the theories must have followed the creation of the masterpieces; when the seekers of metaphysical and spiritual experience found truth and upliftment through them. Theories follow the perfection of the artist's craft and not vice versa.

At the sublime level at which art is discussed many mundane questions germane to the explanation of the art go unanswered. The basic of these is the role of the artist in society and his or her relationship to his art.

Like in most ancient and medieval civilisations the artist was at the service of the religion and its cults. Art was the most effective way of attracting and impressing people and for propagation of religious ideas and icons. This has made the study of the religious history of India easy but it has also made the study of art difficult if not misleading. There is ample evidence that art was an extensive part of the day-to-day life of the people. Murals covered the walls of their houses and themes were not always religious. According to the author of the *Kama Sutra* every citizen was supposed to be accomplished in those arts which could be used to improve the quality of his or her life. Obviously, he was not simply speaking of the quality of the spiritual life of the people.

The pre-modern artists were not self-sufficient producers of consumer art objects. They had to be supported by patrons. Patronage came from bankers, merchants, the nobility, and the priests. Artists were organised through guilds. Both the form and style of most monumental art was a collective articulation of the entire community, the expressions of the lives of the people at a given time or over successive generations, and of what was most meaningful to them. The absence of known artists or the

impossibility of ascribing work to individuals before the Mughal period is because art was mostly a collective expression. More important, because guilds undertook works collectively, segments were assigned to individuals according to their specific skills. Would it be far fetched to assume that this would have hindered an all-round development of the artist and that he or she would continue to be dependent on the group to function? The organisation of the artists in guilds would also have meant more effective control over them.

The custodians of the magnificent temples and other priests depended on the artists for their living. The state too often needed them to give it legitimacy. It is therefore unlikely that either of these two patrons would have dictated artistic terms to the creators of the arts they needed. The artist through his work could affirm or devalue the value system of a society. Control over the artist was thus essential. The material living conditions of the artists would not only reveal their relationship to their patrons but also the position of art within society. The low status assigned to artists in the social hierarchy did not automatically mean a negation of the value of art. In fact it was the opposite. Both the state and the organised religions or cults needed art as it was the most potent and easily disseminated vehicle for their ideologies. Art could inspire awe or belief. Hence they were supported materially and a sublime place was assigned to their work. Artists were kept within the well-defined place in the social and religious hierarchy and continued creating the sublime beauty that would reinforce the system that degraded their social position. How was this contradiction maintained?

A religious-backed social hierarchy which maintained literacy as the exclusive privilege of a small elite had to depend on the artists to spread its message. Art therefore acquired a sacred character and the artist accepted this degradation because he or she believed in the value system of the patron. The artist was compensated by being given ample oppor-tunities to create, and praised for this work in terms of divinity.

It was in the medieval period that this system began to rupture. The infiltration of many racial and religious groups in the preceding period meant that society could no longer be represented by one homogeneous myth or cult. The Muslims who were the new ruling elite had inherited the traditions of other sophisticated civilisations like the Mesopotamian, the Sassanian, and the Egyptian. They had also interacted with the aesthetic traditions of the Byzantines. Changes had to appear not only in the world of art but in the life of the artists as well. It is under the Mughals that we hear for the first time of individual artists and their easily recognisable work. These and other changes are not accounted for in the discussion of the great Indian art tradition. The new process of syncretism between

traditions that were so different from each other is also seldom discussed, nor are the post-Moghal developments.

By the mid-nineteenth century colonialism and the impact of the mercantile economy had made their impact on art too. With the change in patrons, the new rulers and the newly created elite, a major break was made with art tradition and aesthetic consciousness. Without appreciation and patronage Indian arts and artists lost their creativity. The new powers no longer needed them. Along with factory and mill-produced goods came Western artists and art – engravings, litho- and oleo-prints. It was the European artists, often not too competent, who found patronage. The major Indian artist to appear was Raja Ravi Varma who used Western techniques to lay the foundations of Indian calendar art.

This was accompanied by the vilification of Indian arts, particularly the visual ones: they were described as monstrous and grotesque. The many-headed gods and goddesses were mocked and the eroticism of Indian art was condemned as depraved. The nationalists reacted with outrage. Their natural reaction was to reaffirm their heritage. An uncritical acceptance of the glories of their own tradition was a legitimate way to restore their self-respect as a people.

But this uncritical approach today has become self defeating. This emphasis of the Great Tradition denies the pluralism inherent in Indian history. Indian pluralism, instead of being a cultural asset, is converted into political dynamite. Crypto-fascists try to force a uni-lingual, uni-religious and uni-cultural identity over the nation. This means a rewriting of history which often takes on an Orwellian undertone.

The self-image of India as a nation is in a state of flux. Pluralism can only be used to creative advantage by a scientific study of the past and a democratically conceived vision of the future. The artists of today have not only to work within the Indian reality but also to depict it. Only then can their art be relevant.

Saleem Kidwai was born in Lucknow in 1951. He was educated at St Francis School, Lucknow, St Stephen's College, Delhi University and the Islamic Institute, McGill University, Montreal. He has been teaching history, at Ramjas College, Delhi University since 1973. He plans to retire from teaching soon and devote himself to writing full-time.

Ashim Ghosh

SADHUS

Sadhus.... The magical mystery folk. Clad in saffron robes or just skin. Revered by believers as upholders of Hindu religious values. Looked up to as knowledgeable and blessed. Living a frugal life, much in tune with their bodies and their minds ... with nature. A solitary wandering existence, sometimes punctuated with moments of sharing, moments of laughter, moments of song and dance ... of jubilation.... The simple joys of basic human beings.

Radhika Singh writes here on some aspects of asceticism in Indian Society: 'According to Hindu thought, the individual is faced with some very fundamental problems. Notably: the mystery of the origin and nature of the cosmos/universe; and the reason for the continual suffering caused by the pain of sickness, loss, death and misfortune.

The theory revolves around the need to answer these questions and comprehend the meaning of life. Briefly, it states that all phenomena including the all-encompassing universe, emerge from one entity. The name ascribed to that entity is not as relevant as the realisation that all the material/immaterial universe is a part of this one *whole*, and is therefore the *same*. There is only 'one undifferentiated essence'. The 'continual consciousness' of the merging of the human entity with the *universal one*, leads to the transcendence of sorrow and, therefore, of joy.

Before reaching this knowledge the individual/self goes through a series of births, deaths and rebirths (transmigration) which cause suffering. Once the fact of *oneness* is felt, man reaches a realm of 'birth and bliss, beyond birth and death, joy and sorrow, good and evil'. He is completely free. To oversimplify – infinity/eternity 'resides in the human soul – it is the human soul'. And this realisation brings peace, and therefore an end to pain. The knowledge is hard to reach when the mind is cluttered with material care and desire. Thus, this brings us to the origin of, and the need for, the practice of asceticism.

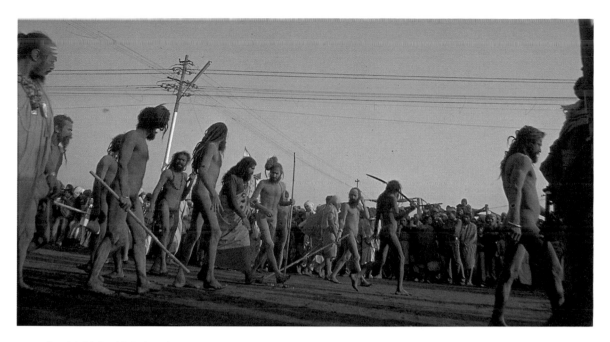

Kumbh Mela, Allahabad

Asceticism is a lifestyle pivoting around spiritual renunciation. The Indian word for ascetic is 'sadhu'. The word 'sadhu' in Sanskrit means 'good man'. A sadhu is one who has been initiated into an ascetic sect to devote himself to achieving release from the cycle of death and rebirth. Detachment from social affairs leads ideally to a life of celibacy and selflessness. Sadhus do not work, but are dependent on alms and donations. They wander from one pilgrimage centre to another, visiting religious sites and teachers, and practising mental and spiritual exercises in meditation.

Itinerancy, deterring the accumulation of property and personal ties is thought to promote the spirit of renunciation. Through spiritual practices sadhus gain religious sanctity and therefore, authority. They are venerated by society as holy men since they are seen to be closer to the Ultimate Truth. Society provides them with material support, in return for which they act as spiritual advisers, teachers, doctors and counsellors. Historically, as wanderers, they have played an important role in the dissemination of religious and folk traditions through the different regions of India.

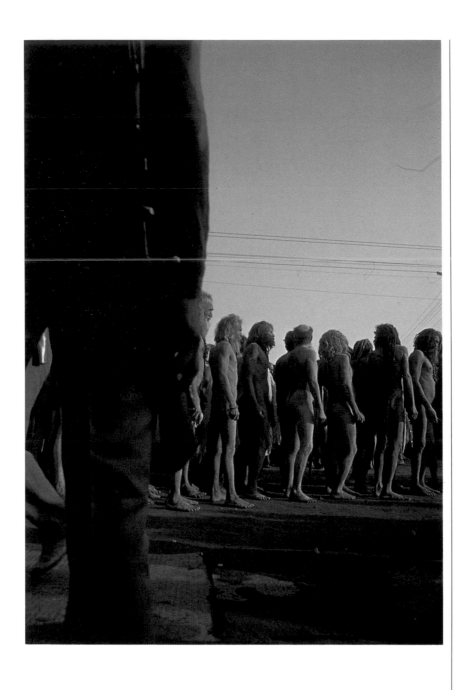

Kumbh Mela, Allahabad

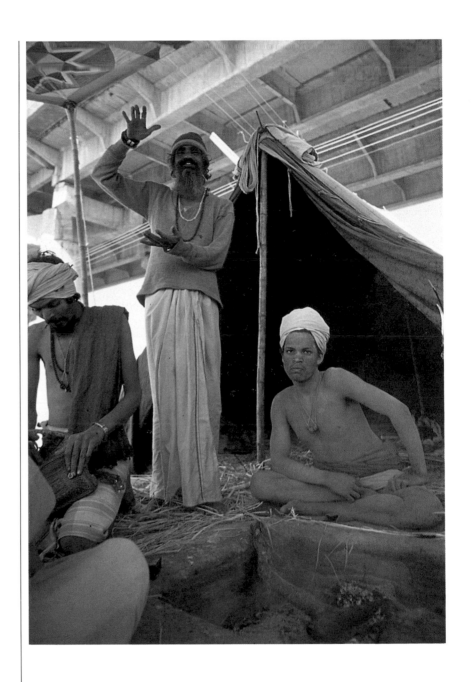

Kumbh Mela, Allahabad

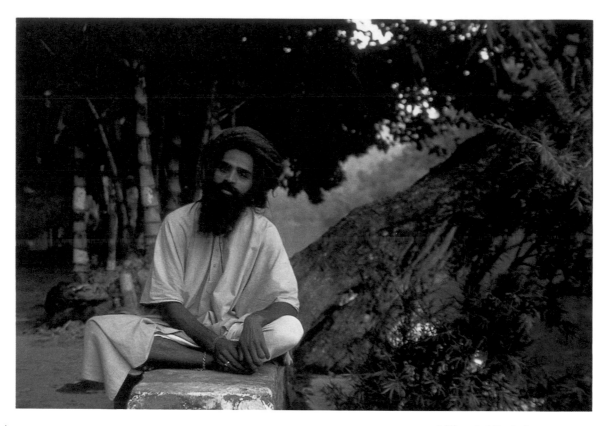

Himachal Pradesh

Though divided into many sects, and separated from each other by ident-
ifying life-styles, practices and insignia – the sadhus are homogeneous in
their endeavour to exist within a different conceptual world. The continual
presence of this religious order reaffirms the existence of the living belief
in Ultimate Truth – which is another word for *Nirvana*.'

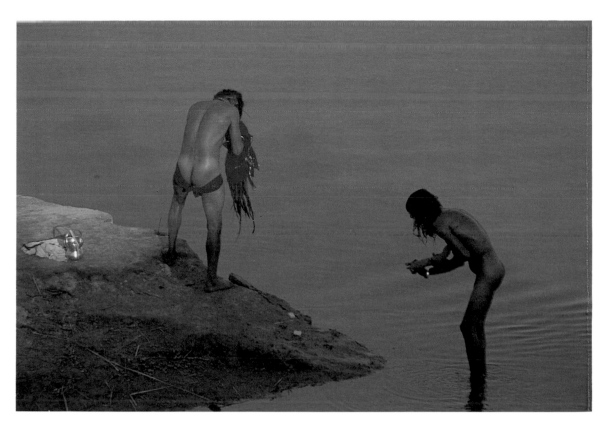

Kumbh Mela, Allahabad

Ashim Ghosh was born in 1962 in Newport. Over the past five years he has completed a large number of commercial assignments: calendars, corporate brochures, advertisements, audio-visuals, travel brochures, and so on. But in the last year and a half, he has been concentrating on, or rather trying to be aware of, the various aspects of life and what it conveys to him. His work, as far as possible, is done candidly since he follows a policy of complete non-interference with another's space and privacy: intrusions of any kind are strictly avoided. The pursuit is one of capturing a moment, complete in its information, sensitivity, emotion and value. A moment which spells the reality of life as it is. He plays bass guitar with an electric band and has performed in scores of concerts around India.

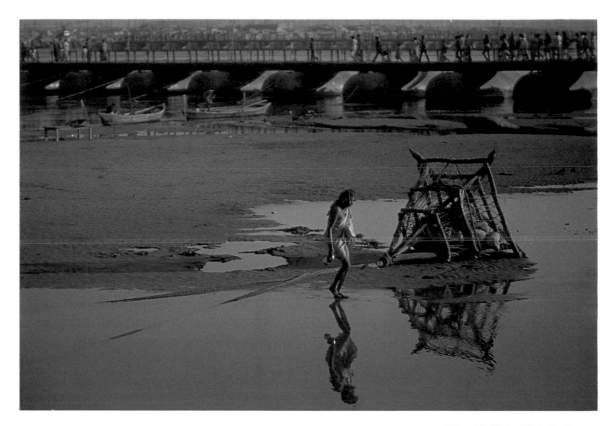

Kumbh Mela, Allahabad

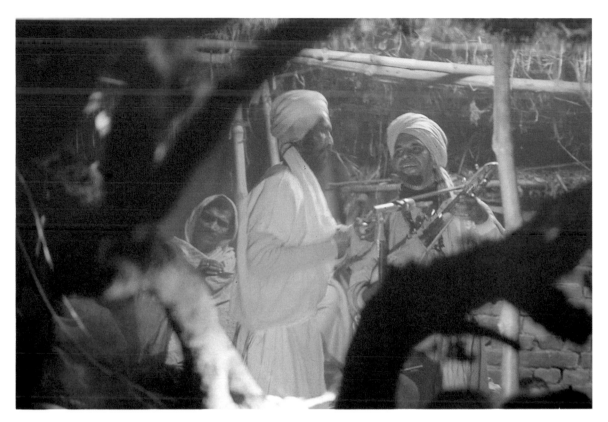

Kumbh Mela, Allahabad

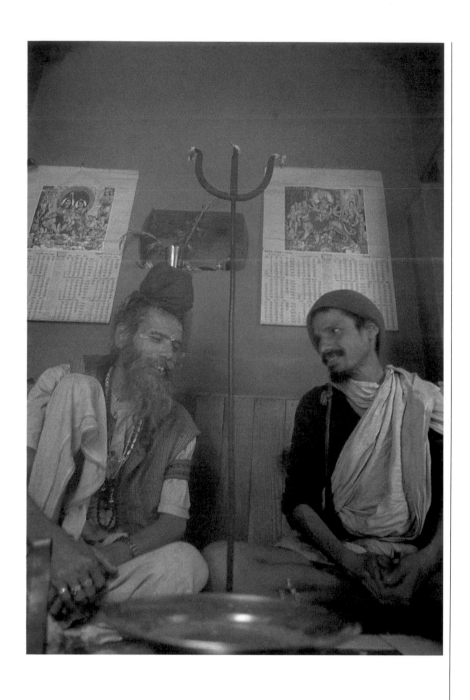

Jageshwar

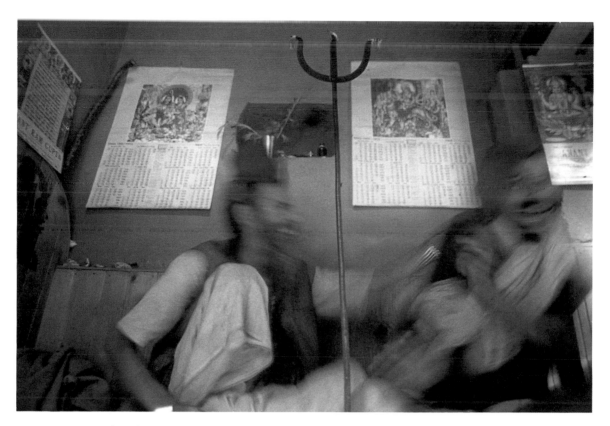

Jageshwar

Religion's a wonderful habit
If it didn't turn man into rabbit
Set him apart
And give him a start
On Heaven 'fore another can grab it

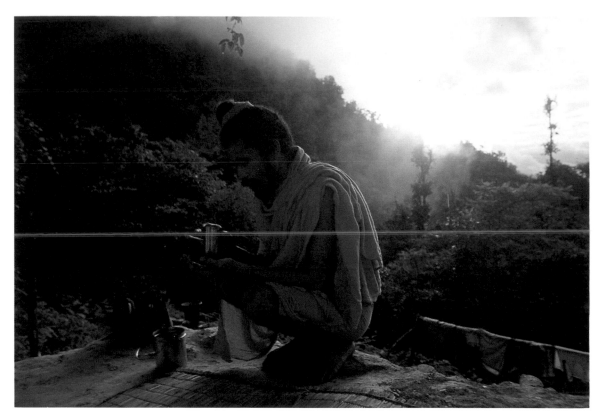

Himachal Pradesh

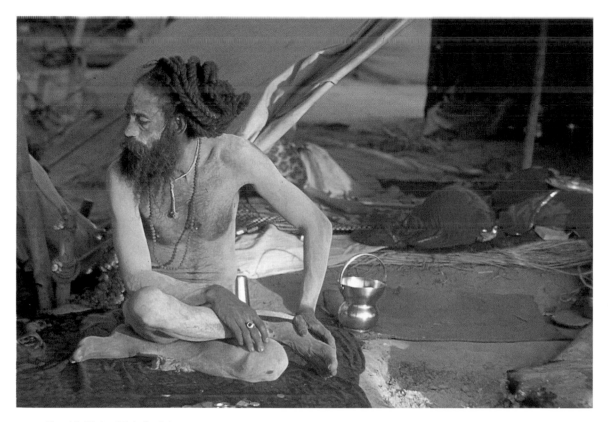

Kumbh Mela, Allahabed

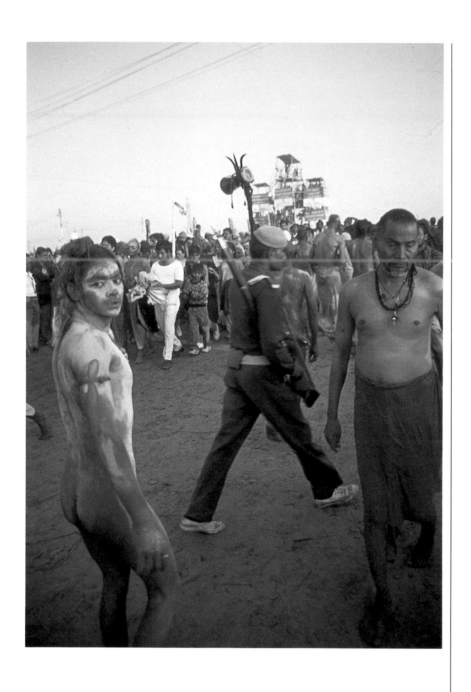

Kumbh Mela, Allahabad

Amita Prasher

VEILED STITCHES

My work is a tribute to women's creativity and also a record of the many changes that are being enforced on women as old skills are lost, and commercialisation introduces new pressures.

Social and religious norms have prevented Indian women from entering the world of commercial craft and, until recently, they enriched and enhanced their environment by painting their walls or making embroidery for their daughters to carry as dowry to their husbands' homes. These crafts were home-based and often linked to specific events – births, marriages, festivals or rituals. Because it was not marketed this art has been seen as merely decorative.

My work explores the lives of a few Meghwal women living in the remote village, Alamsar, Barmer District, Rajasthan. In this region every girl, every woman carefully embroiders exquisite patterns and colours for herself and her groom in an expression of her celebration of life in her harsh and sometimes dreary existence.

Each day, girls and women spend about 3–4 hours collecting water, the vital element for life in the desert. Their other working hours are spent collecting fuel for cooking, washing, looking after children, cattle and working in the fields. Between these chores they manage to snatch a few hours to embroider. A piece of embroidery therefore can take anything from 10–30 days depending on the intricacy of the stitch.

But with years of successive drought and war, the women's embroidery became the only marketable skill in these desert wastes.

The large-scale commercialisation of crafts while drawing women into the economic mainstream has, however, increased exploitation. Many of the skills have been adapted to market demands by shrewd businessmen without women necessarily deriving the benefits from this. Her goods are bought cheap and sold dear with the middleman pocketing the profit.

Desert songs

Work being scarce and monopolised, the woman protests silently by embroidering 'rough' or poor quality stitches that are quicker to do, and has affected the overall quality of work available today. Does the consumer or traveller who buys the ethnic and exotic ever see or think of the woman and process involved in the embroidery? This is a question that the 'Veiled Stitches' has attempted to answer in coming closer to these women, their struggles and joys in fulfilling their many roles as child, woman, wife, mother and craftsperson.

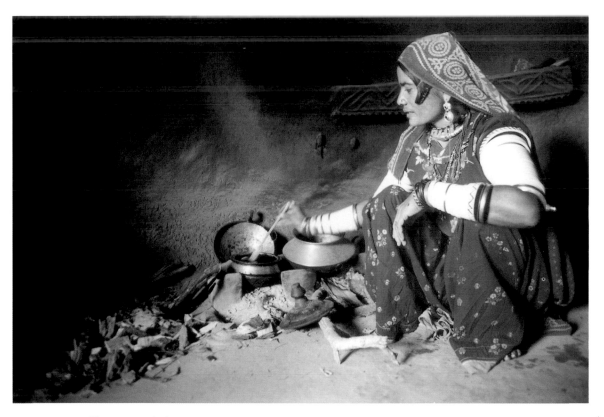

The sparse stir

Amita Prasher was born in 1961. She read political science at Delhi University and a post-graduate diploma in journalism for developing countries at the Indian Institute of Mass Communication, Delhi. She speaks Hindi, English, Bengali and Marwari. She has been working with Indian and international development agencies for the past seven years, developing audio-visual and other communication resources. The projects have been dealing with a variety of issues such as health, education, legal rights, appropriate technology, environment, craft and traditional media.

This work has meant she has travelled through some of the remotest villages of the country interacting very closely with the people especially the women.

Working with the simplest communication technique, the 'visual', the central and strongest element, is an important part of her work.

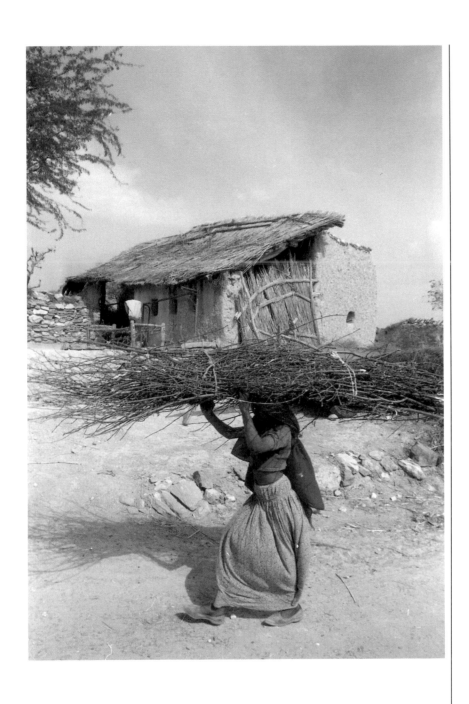

The eternal collect

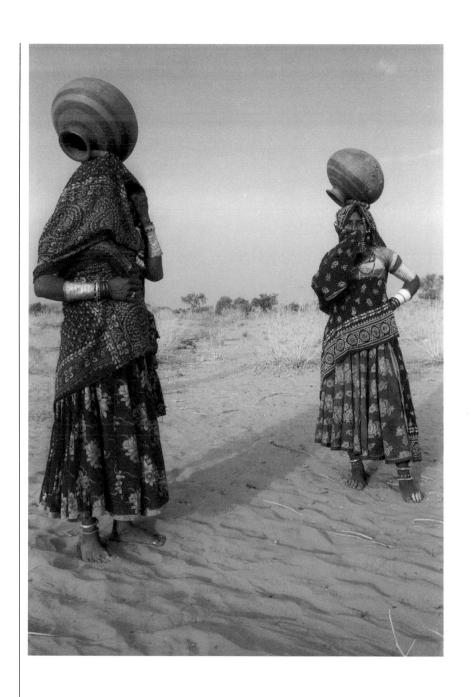

The eternal collect

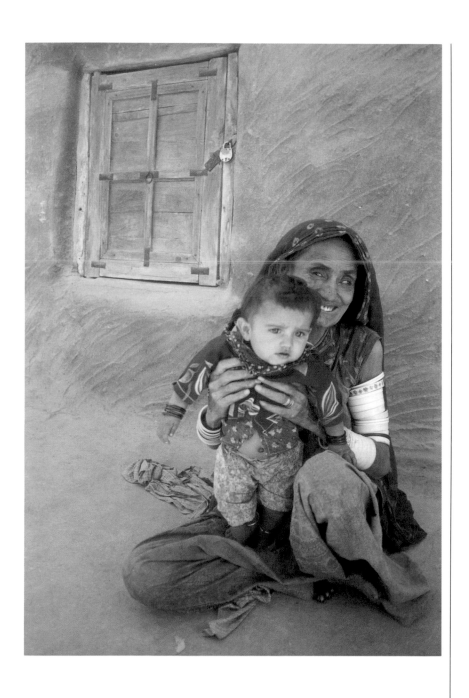

Generating care

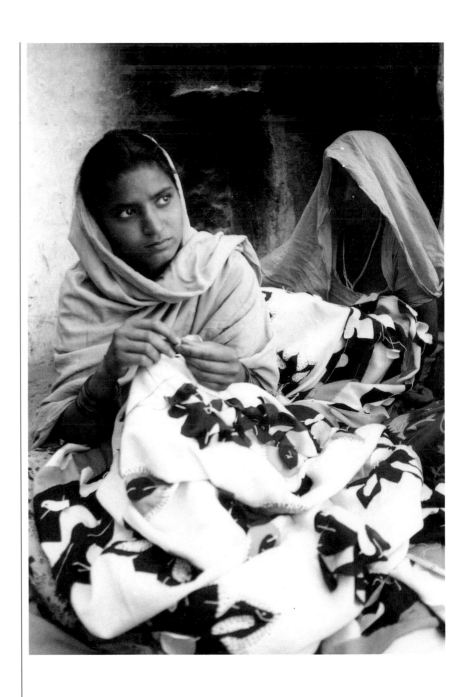

The generating stitch

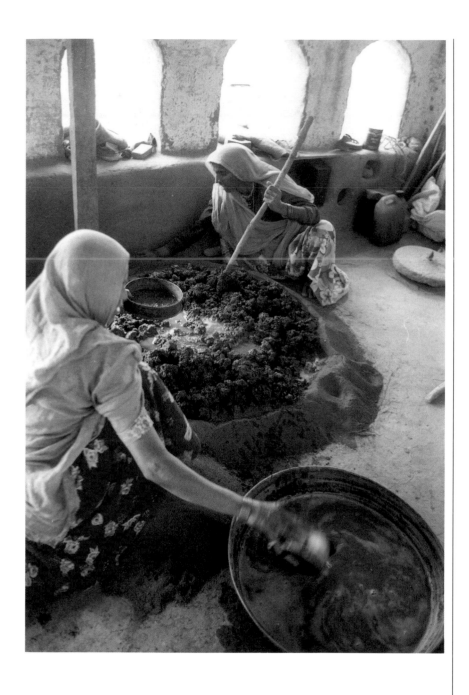

The wheel

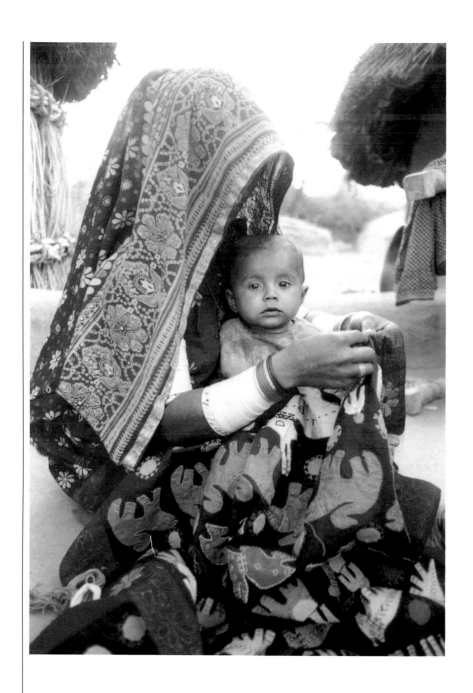

The veiled stitch

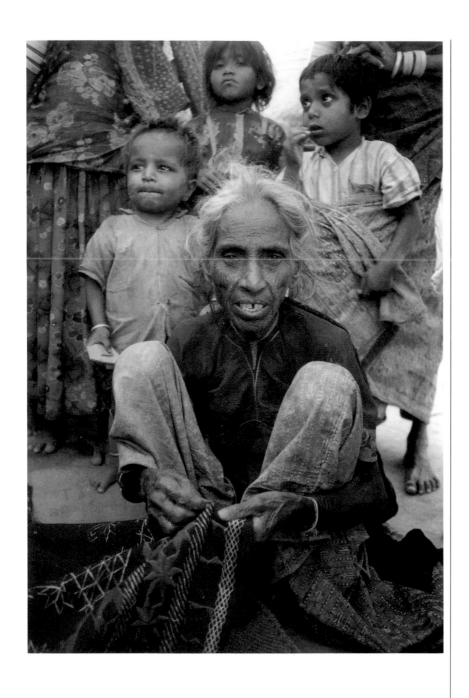

Tired generation

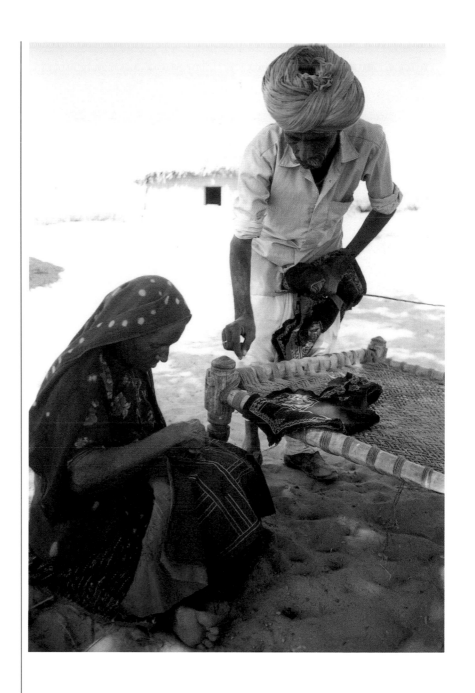

The middle hitch

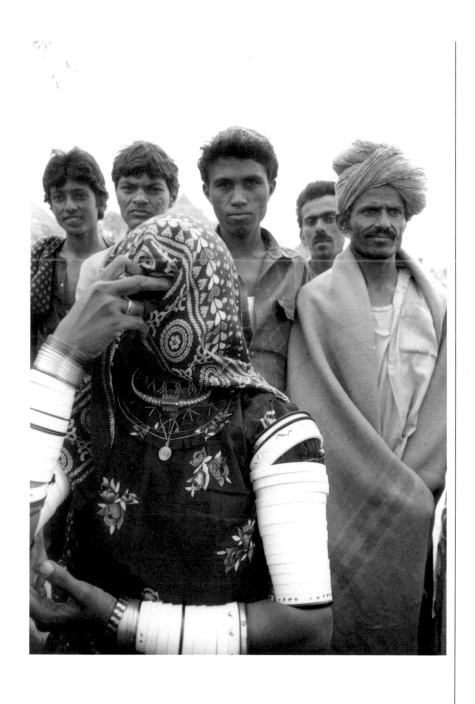

Veiled domination

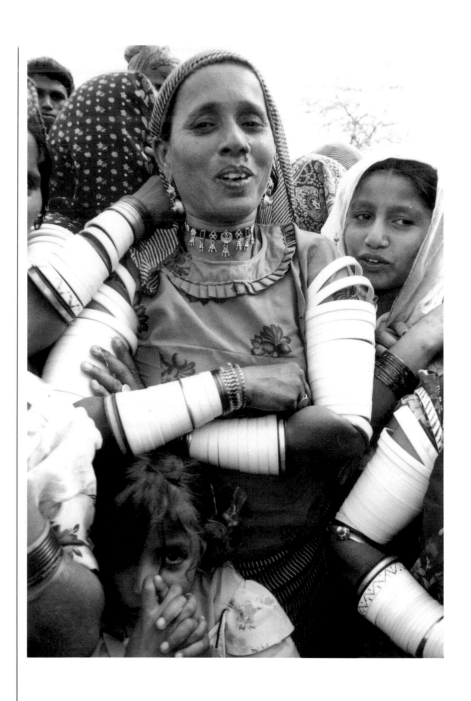

Desert spirit

Ram Rahman

DELHI: a snapshot diary

*T*hese photographs are pieces of a snapshot diary which I have been assembling in Delhi, where I was born. We lived in New Delhi, a bureaucratic city laid out by Edwin Lutyens in the 1920s which served as the stage-set for the last days of the Raj. It still serves as a backdrop for enactments of Raj nostalgia, now performed by Indians. The *Statesman*, a newspaper founded by the British, and still very English in its culture, sponsors a vintage car rally which begins and ends at Lutyens's India Gate. It serves as an occasion for people to dress up and enact fantasies of a bygone age. For this they might even win a silver cup, presented by the Naval Chief. They might, of course, be nouveau-riche businessmen who have bought the vehicles and accoutrements from now-impoverished, ex-royalty. The lawns of New Delhi are the set for the winter lunch-time siesta, when every clerk of the Government of India can be found supine while the business of government waits. New Delhi is also where the ruling and professional elite live. Their homes, with the stools, handloom fabrics and art, both old and new, are a display of a new post-Independence culture, presided over by the ghost of Nehru.

The old city of Delhi is different. Badly decayed, it has still a vestige of the urban culture from pre-British days. I explored these dense streets with their theatre after we moved to a small flat outside the northern gate of the old city wall. The vibrancy of the street is a sharp contrast to the slow drama of governance in New Delhi. Small tradesmen flourish in the shadow of the mosque, selling bits of springs, bolts and scrap. Goats are fattened and nurtured for the sacrifice at Id. Ear cleaners ply their trade, using the sun to peer down the ear canals of their clients; they wear the squat red turbans which indicate their hereditary profession. Masseurs parade in black, and women can have their hands and feet decorated in henna. The open grounds which now lie between the old city and the Red Fort were created when the British razed those neighbourhoods after the First War of Independence in 1857. They are now used to set up the tents of the visiting circus from Kerala, for fairs, and for erecting the huge effigies of Ravana burnt in October during the Hindu festival of Dussehra. Shirts can

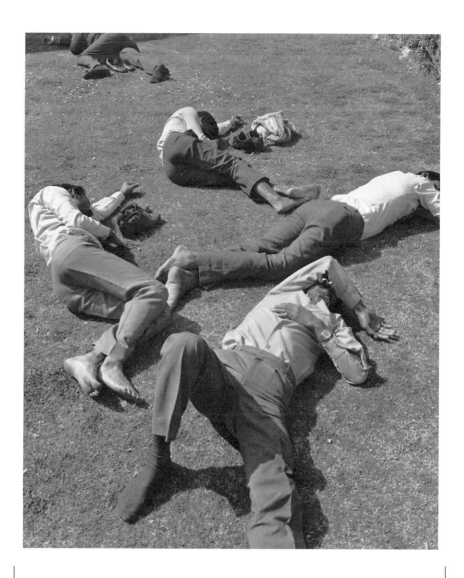

Government clerks, winter
lunchtime (1989)

be bargained for while waiting for a bus, and on Sundays, local residents
can be found betting on their favourite wrestlers from the Akharas (Gym-
nasiums) on the riverbank.

Politics is the lifeblood of Delhi. I followed Devi Lal, the leader of the
Jat farmers from neighbouring Haryana, when he campaigned in the
tumultuous General Election in November 1989. A deeply sceptical crowd
slowly gathered at a stop he was to make on the city outskirts. He made
it a point of appearing just after the episode of the Mahabharata serial on

Old Delhi street signs (1989)

television, which was shown on sets erected on a podium. His bus pulled in, and Devi Lal rose on a creaky hydraulic lift through its roof, accompanied by election songs set to the most popular film music hits of the year with new words by his party hacks. The lyrics deride Rajiv Gandhi and his Congress (I) Party, which then lost the election. Politics, and its increasing brutality, also lead to the death of my friend, the actor Safdar Hashmi. Safdar, a member of the Communist Party (Marxist), was a charming, talented and idealistic artist. He led his street theatre troupe out to another of the city's outskirts, on New Year's morning, 1989. While performing on a street corner a play on trade union rights and factory creches for working mothers, he was singled out for attack by a local hoodlum (and aspiring politician) allegedly supported by the ruling Congress (I) Party. He managed to save his actors, including his wife, before

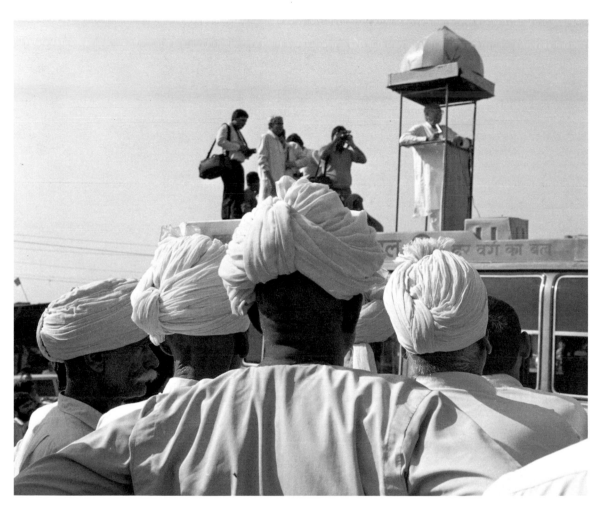

Jat farmers leader, Devi Lal, rising on a hydraulic lift from inside his campaign bus to address his followers, Delhi outskirts, General Elections, November (1989)

his head was beaten to a pulp on the pavement, and he was dragged by his feet down the narrow lanes between the houses – a lesson to the inhabitants. Safdar took a day to die, which led to an unprecedented outpouring of protest by artists, workers, and people of all classes, who followed his body to its cremation. Delhi has never seen a funeral like it.

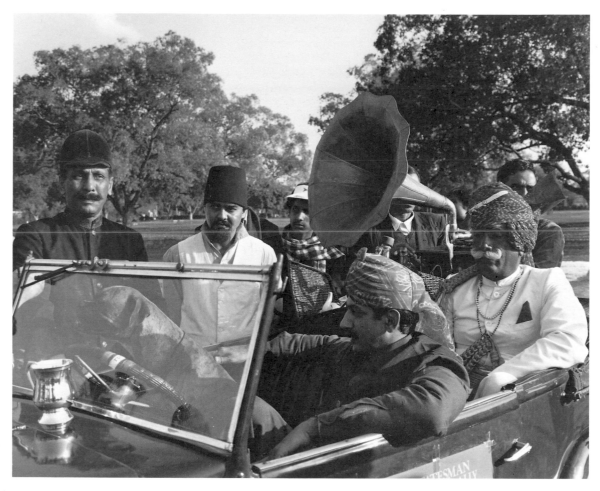

The Statesman Vintage Car
Rally, India Gate (1988)

Ram Rahman was born in Delhi in 1955. His interest in photography developed
while reading physics as an undergraduate at MIT. While there, he studied
extensively with Johnathan Green, and did workshops with Minor White and
Harold Edgerton. He also studied with the historian of photography, Eugenia
Parry Janis at Wellesley College. He went on to obtain a Master of Fine Arts
degree in graphic design from Yale University in 1979, where his thesis
examined the relationship between typography, photomontage and the *avant-
garde* cinema, particularly in the Soviet Union between the wars.

Since 1985 he divides his time between New York City and New Delhi, working
principally as an architectural photographer. Exhibitions include: *Artists Protest*

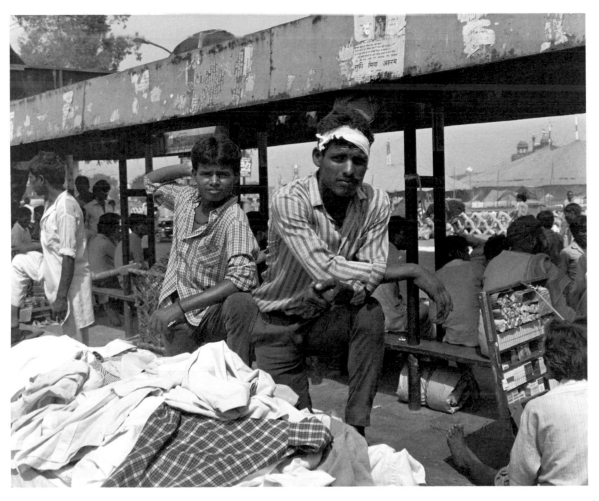

Street shirt vendors, opposite
Red Fort (1989)

(In Memory of Safdar Hashmi) Rabindra Bhavan, New Delhi (1989); *One Man Show*, Shridharni Gallery, New Delhi (1988); *Vistara: The Architecture of India*, Bombay, Moscow, Tokyo (1987); *Kham: Space and the Act of Space*, New Delhi (1986).

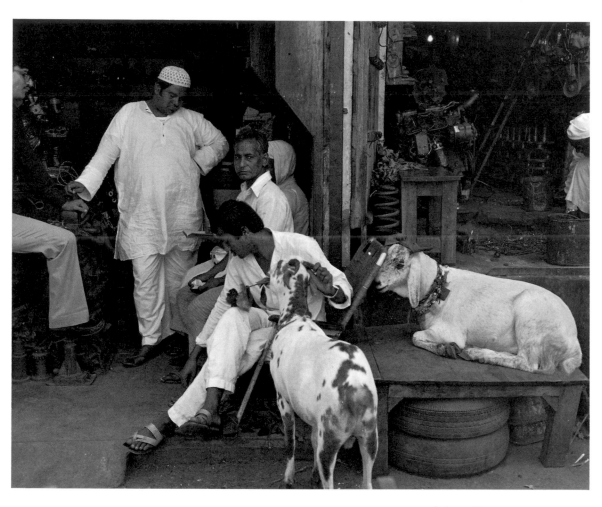

Jama Masjid car-parts dealers,
Bakr-Id, with sacrificial goats
(1983)

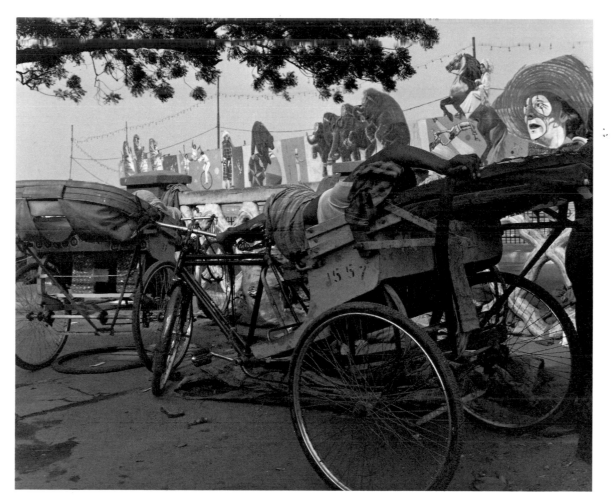

Rickshaw driver visiting
circus, Red Fort grounds
(1988)

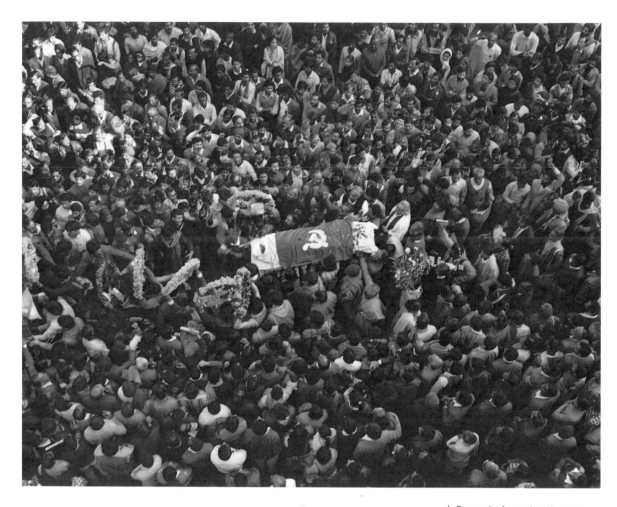

Funeral of murdered street
theatre actor and activist
Safdar Hashmi, 3 January,
1989. Safdar, a member of the
Communist Party (Marxist),
was beaten to death while
performing in the industrial
outskirts of Delhi, allegedly by
followers of the then ruling
Congress (I) Party of Ranjiv
Gandhi

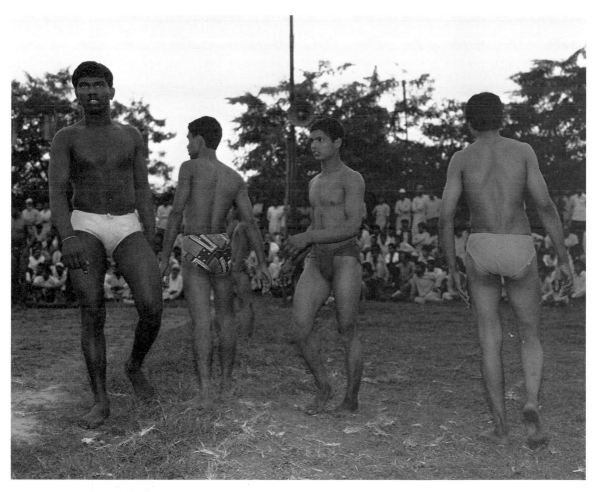

Wrestlers on Sunday, Jama
Marjid (1989)

Sign painter (1983)

Street ear cleaners, Chandni
Chowk (1989)

Waiting for an election
meeting Rohtak Road (1989)

The police is a force to protect us
From social diseases that infect us
Like those with no money
Who try to act funny
Have the cheek to want to reflect us

Sheba Chhachhi

FEMINIST PORTRAITURE

*I*n calling these portraits I am aware of colliding with the classical notion of a portrait 'capturing the essence' of a person in a single image. In fact, the more I get into this work, the more I feel that this must be done. For, in attempting to fracture the image of a militant, struggling woman, I am aware of the stereotype that I created/contributed to in my earlier work and that I could as easily create another stereotype through the constructed images that I am building today.

These women are plural, contradictory, multiple. Any one image excludes the other; why should one choose a particular photograph, privilege one over the other? I am attempting to build composite images of these women, sometimes, but not always, including earlier photographs – each woman seems to demand a somewhat different constellation so the structure of each portrait varies, as do the women themselves.

The two portraits here represent the spectrum of Indian feminist activists; one is *Shahjahan 'Apa'* a working-class mother who was mobilised by the 'Dowry' death of her daughter; the other is *Radha*, a young academic.

Sunil Gupta writes:
'Chhachhi, having arrived at photography via her involvement with the Women's Movement in India, developed a classical documentary style. We know such work as "Positive Images". "Positive" in the sense that they seek to redress a balance where the vast majority of images suggest a negative stereotyping of the subject – in this case, Indian women.

'More than a century of documentary practice has provided all sides of any political argument with a pool of photographs to illustrate their points – photographs whose usage has remained out of the control of the photographer. At the turn of the century Lewis Hine took photographs for a specific campaign around the issue of child labour in New York. The propagandist use of documentary photography has been recognised by the

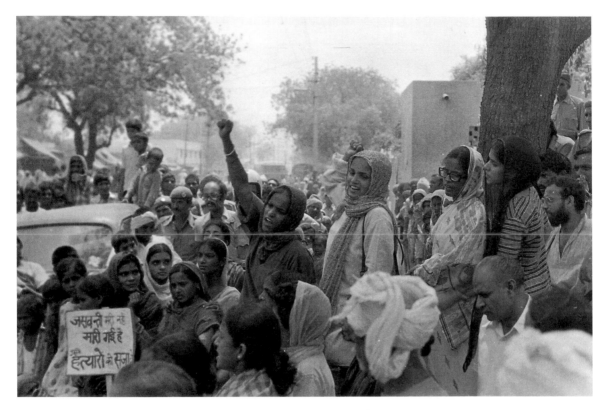

Women's Rights
demonstration, Delhi (1980s)

state at least since the time of the Russian Revolution and, during the
Second World War, photography developed into an organised machinery
of control and dissemination.

'In the 1980s, amongst feminists and others on the left, a crisis of visual
representation occurred, both in India and the West – was it sufficient to
record in a straightforward manner people in the "correct" political con-
text? Or was it more pertinent to challenge the dominant modes of rep-
resentation: the media's use of documentary photography? Put another
way, the debate polarised around the "representation of politics (positive
images)' and the 'politics of representation".

'Chhachhi, moving from one position to the other continues to question
the validity of singular modes of seeing, demonstrating the pressures placed
on Indian photographers to come to terms with their medium without
having the support of critical theory provided to their counterparts within
the West.'

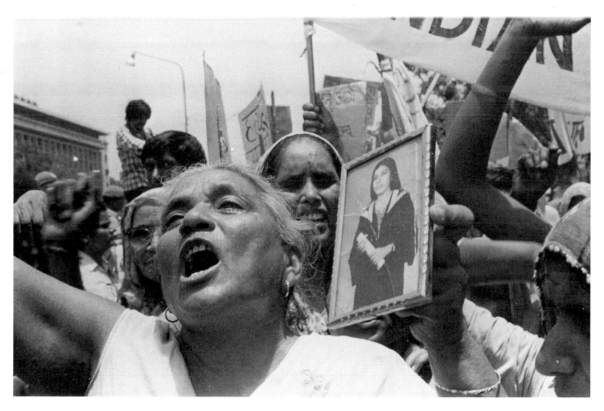

Women's Rights
demonstration, Delhi (1980s)

Sheba Chhachhi has been making graphic, photographic and audio-visual
material on social issues at 'Lifetools' an independent design unit, for the
last ten years. Her design work has included 'Notebook '88', the first feminist
diary in Hindi and her audiovisual work has included *Listen, Women Speak Out
on Slum Resettlement* – an analysis of the sexist bias in urban planning. An
active feminist and a founder-member of 'Jagori', a women's training,
communication and documentation centre, her photo-documentation of the
Women's Movement in Delhi, 1980–8, was exhibited in *Four Indian Women
Photographers* as part of the Spectrum Women's Photography Festival, at the
Horizon Gallery, London (1988). Since then she has moved out of the
documentary mode somewhat and is attempting to use the camera to explore
subjective realities through both constructed and documentary images. She
also works with clay, building terracotta sculptures and hopes to bring the
clay and photographic images together in a multi-media exploration of the
feminine.

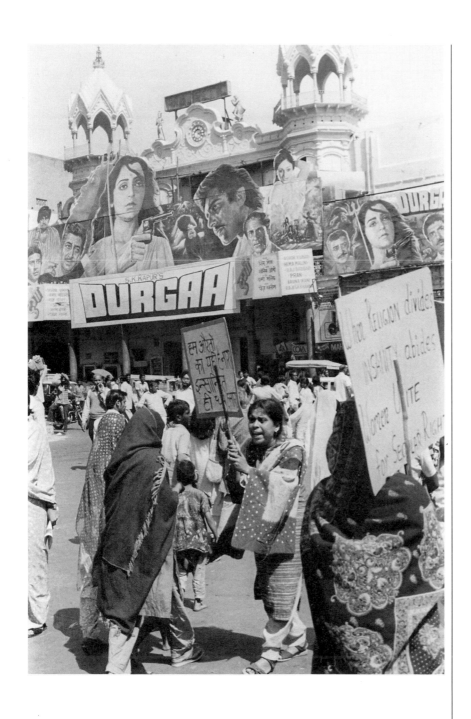

Women's Rights
demonstration, Delhi (1980s)

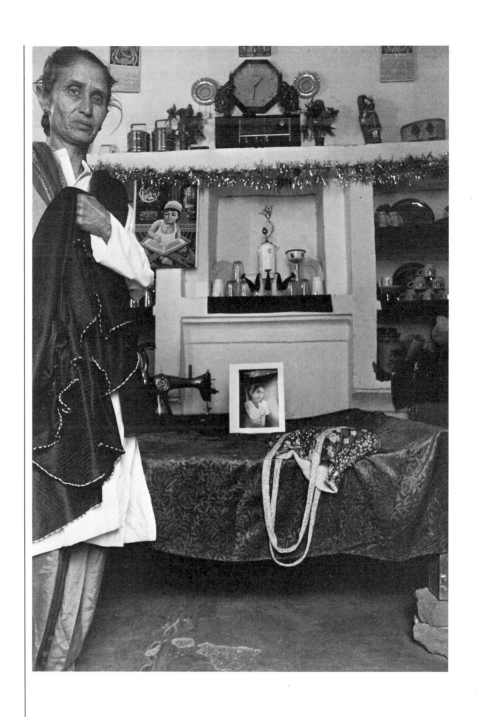

Shahjahan 'Apa' – a portrait
(1980–90)

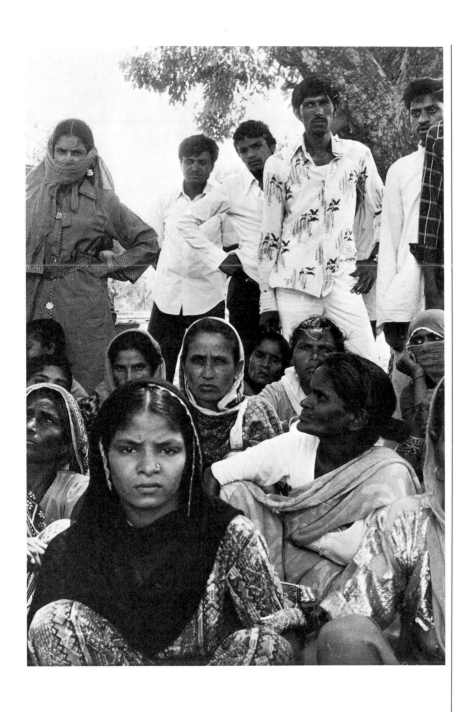

Shahjahan 'Apa' – a portrait
(1980–90)

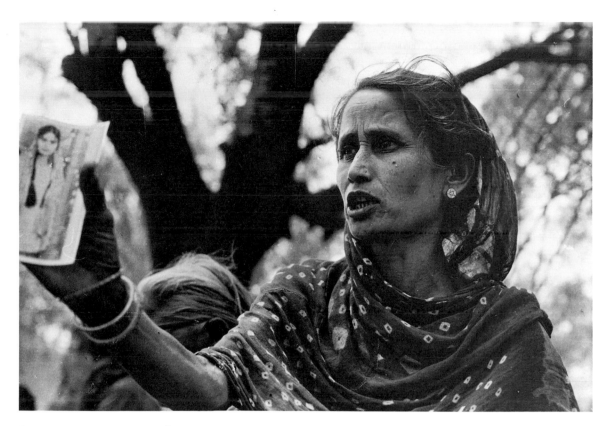

Shahjahan 'Apa' – a portrait
(1980–90)

Now women are beautiful creatures
Who do have a whole lot to teach us
But beat them up well
And make their life hell
Lest they join their hands and impeach us

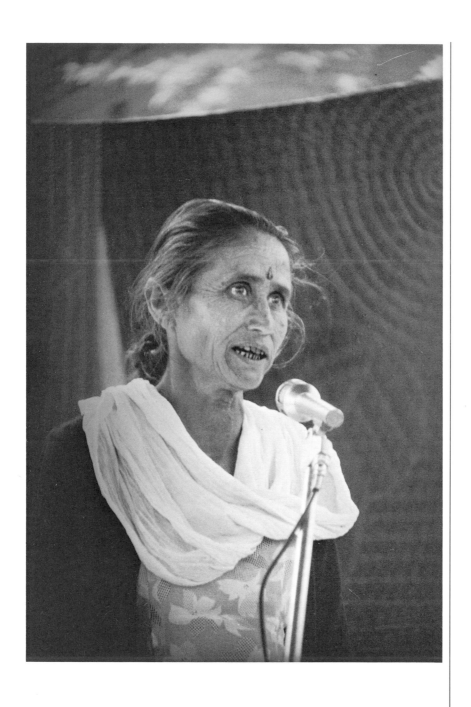

Shahjahan 'Apa' – a portrait
(1980–90)

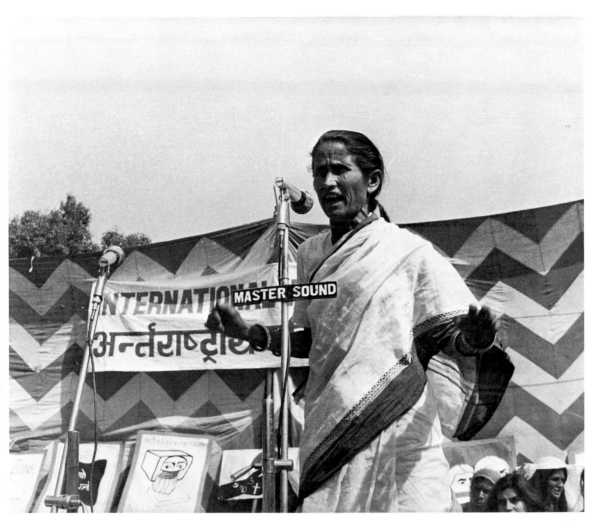

Shahjahan 'Apa' – a portrait
(1980–90)

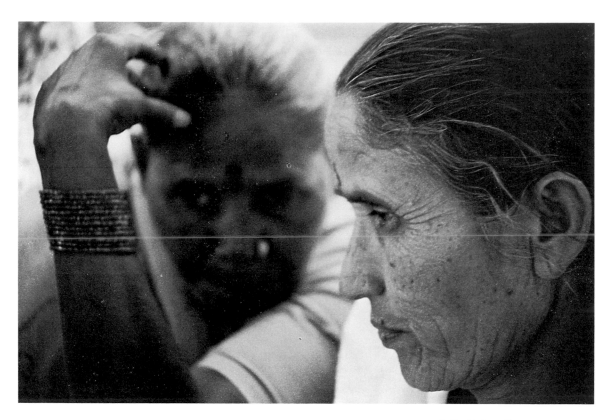

Shahjahan 'Apa' – a portrait
(1980–90)

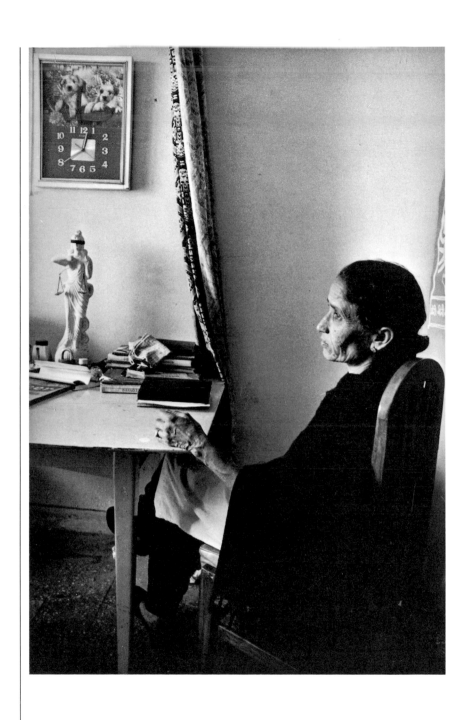

Shahjahan 'Apa' – a portrait
(1980–90)

Radha (1990)

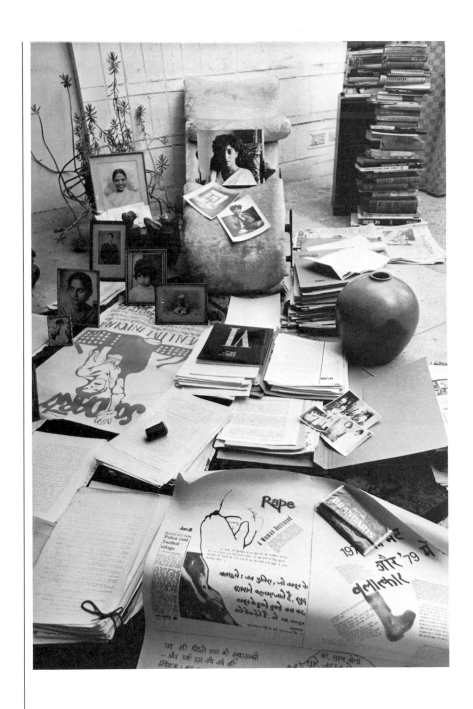

Radha (1990)

Karan Kapoor

ANGLO-INDIANS

As an Anglo-Indian, my interest in photography began by researching the older generation at The Tollygunge Home for Anglo-Indians in Calcutta. I then went to photograph them in Bombay and Ooty. I was more interested in the older generations, as they seemed to be the last remaining remnants of the British Raj – people who remembered the railway cantonments, the Marilyn Monroe look-a-like contest, the 'Central Provinces', and so on, a world long gone.

Mass migration to Britain, Canada and Australia left behind fewer than 100,000 of the estimated 250,000 at the time of Independence (1947). Those I photographed have remained mostly because they could not afford to leave, although most had relatives living abroad.

They were first called Eurasian and were officially designated 'Anglo-Indian' in 1911. They were at the bottom of the social order: the class system created for British India was not very different from the Indian caste system and rigid hierarchies prevailed. Provided with special jobs on the railways, police force, customs, and armed forces they rarely held more than subordinate positions.

A lot of the Anglo-Indians I met called themselves European, probably because the Anglo-Indian was never accepted in British Indian society. They believed (and were brought up to believe) that Britain, not India, was their mother country. They were loyal to the British during agitations and the 'Mutiny' of 1847. This created animosity with the Indians; but the British remained suspicious of the Anglo-Indians because of their roots in India.

My pictures are of the elderly. I was struck by their extraordinary resilience, their total lack of morbidity, their abundant joy and their zest for living. For people at the Homes there wasn't much to look forward to, only the annual dance. Myrtle who was 71, and still an outrageous flirt, admitted, 'It's impossible to remain faithful to one man', and that she had 'barely enough money to buy lipstick and talcum powder for the dance'.

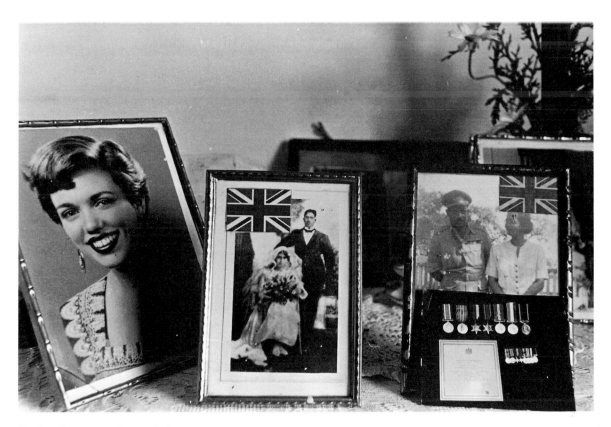

Daphne Sampson, winner of the Marilyn Monroe look-a-like contest, 1956. She now lives in the Lady Wellington Home, near Bangalore

The confusion of people caught in the cross-current of the racial divide is obvious. Peggy has two sons living in Calcutta married to Indian women. She says 'I couldn't possibly live with them for one day, my God!'

At the Homes they seem to be exiled from a rapidly changing world: the last of India's Anglo-Indians live out their years in a colonial atmosphere sheltered from the 'Indian' society they cannot cope with; the Anglo-India they know lives on. Here there are no difficult adjustments to be made. And here the last of a breed will slowly fade away.

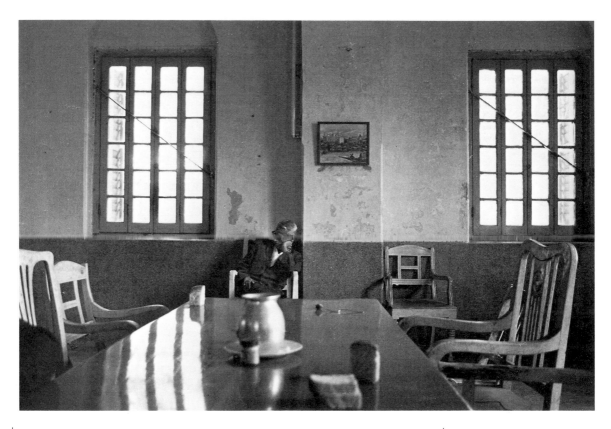

Tollygunge Home, Calcutta

Karan Kapoor was born in Bombay in 1962. After his studies he was apprenticed to the film cameraman Govind Nihalani between 1980 and 1982. He worked freelance for Indian publications such as: *Indian Express*, *Keynote*, *Sunday Observer* and *India Today*. In 1983 he worked on the film 'The Bostonians', and since then has assisted photographers: Erica Lennard, Mary Ellen Mark and Calliope in New York and until 1989 he worked in New York on fashion and theatre portraits. His work has been exhibited at Danceteria (NY) and at the Festival of India (Moscow) 1987. A story on fox hunting in India appeared in the *Observer Magazine* in 1990. His most recent project was to document the Alcoholic Rehabilitation Centre in Southall.

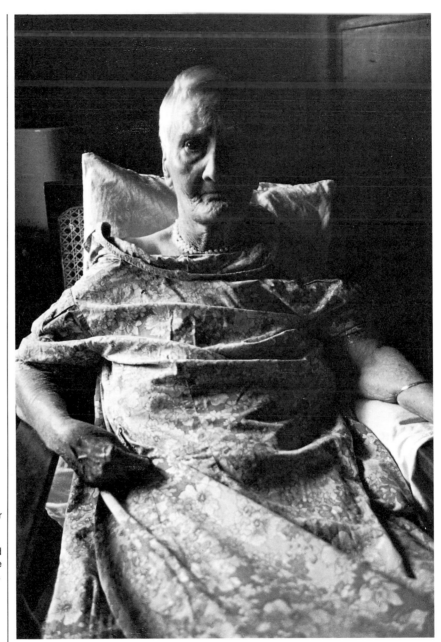

Mellicent Blanche Jones

Haughty, difficult, beautiful, Welsh, pampered by the servants who she insists should call her Missy Baba. For Mellicent, 1947 almost never happened 'We hate the Indians' she says and a second later 'We love the Indians, love them'. Her wondering, raging, lonely mind grasps only occasionally a reality that seems to constantly shift focus.

Unwittingly, her jagged sentences give me the most telling and painful insights into these old men and women who sit patiently in the long corridors; last travellers waiting for a train that has not come

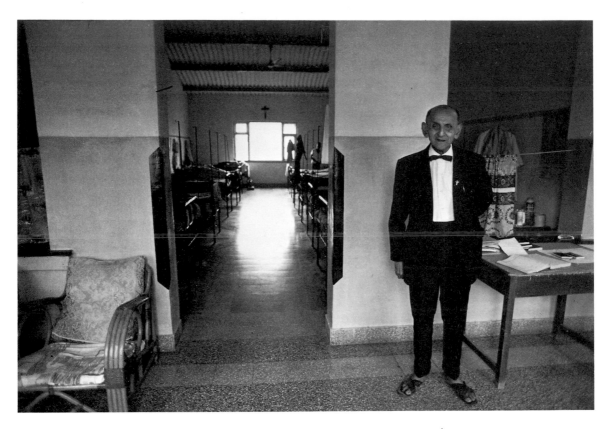

Stanley Peters

Ever since his wife died, he
wears only mourning clothes.
He does not drink or swear and
writes poetry to his wife

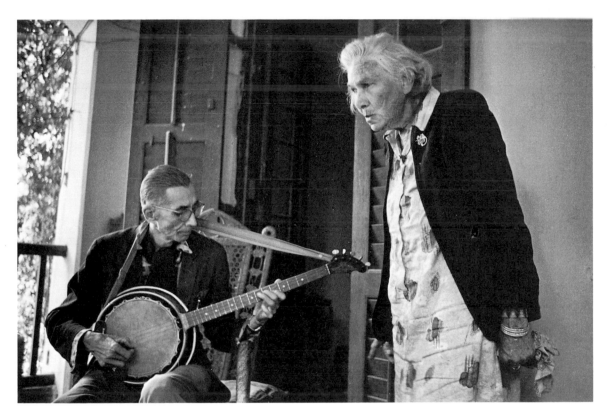

Mr and Mrs Carpenter

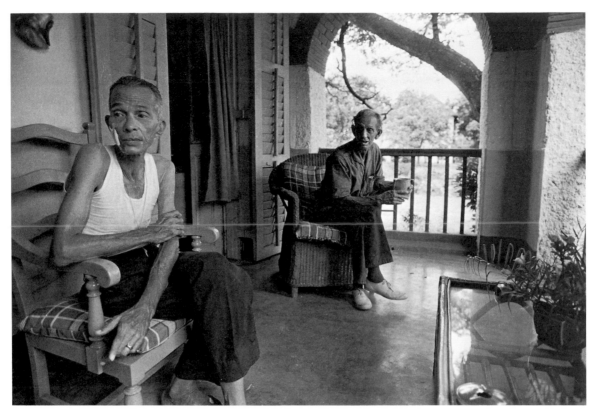

Now suppose that a gent should get flighty
And begin to act high and mighty
Our little sane world
With its little lost herds
Can pity him with pure, pious piety

Archie Archibald

In 1932 he was the manager of 'Flurys', a cake shop on Park Street, Calcutta where: 'When you walked in there you knew you were in a place of aristocracy, the cream of people went there.' Lost his job shortly after Independence. His last possession, a Dalmatian dog, he sold for Rs.30. 'You know my dear boy, obligation and poverty is a very grave crime'

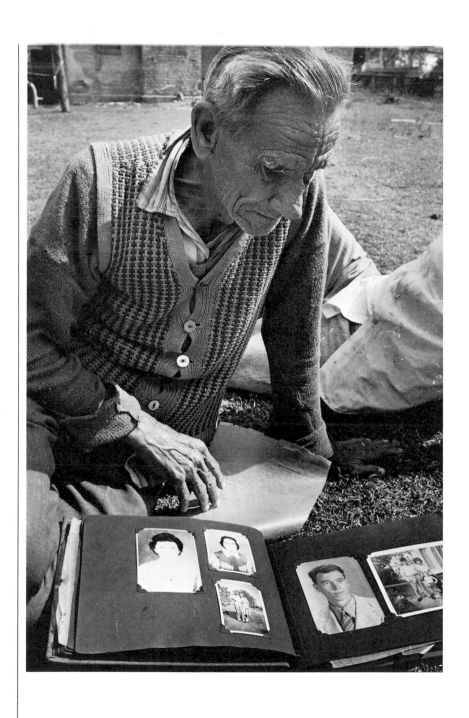

Mr Smyth – ex-engine driver

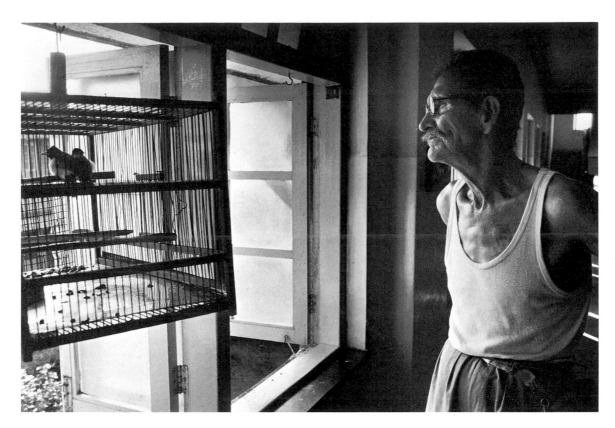

William 'The Handyman',
Bombay

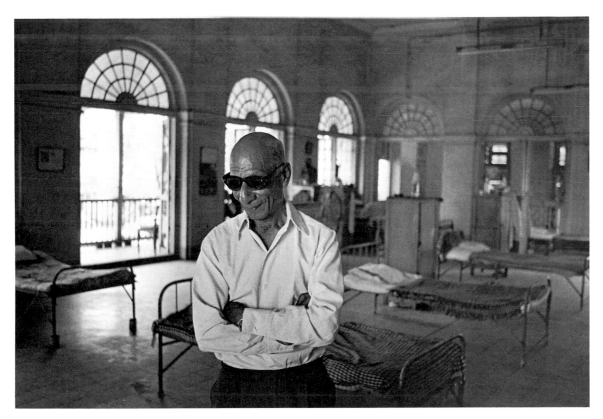

Home for Anglo-Indians,
Lovers Lane, Bombay

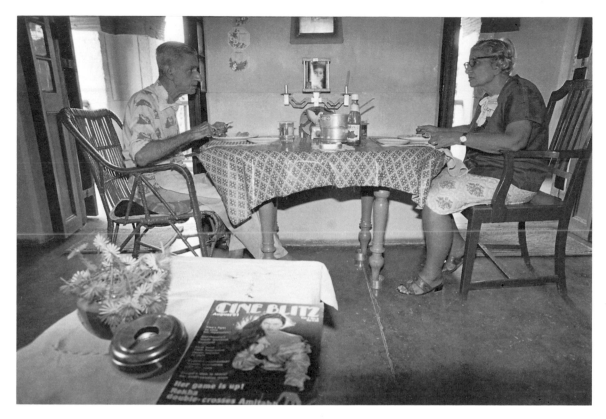

Calcutta

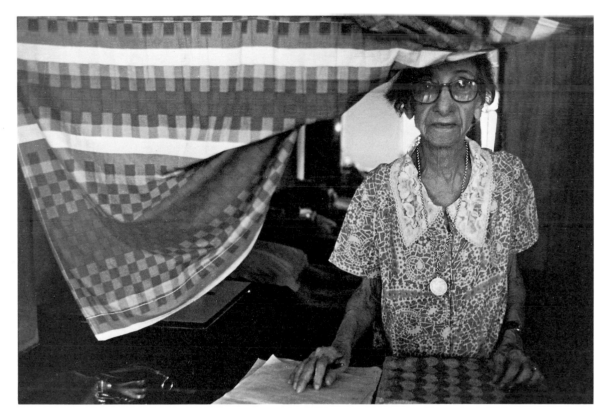

Calcutta

Calcutta

Ketaki Sheth

BOMBAY PORTRAITS

*T*he pictures in this portfolio are from an on-going photography project on Bombay, the city where I live. Rather than use an objective approach, I am creating a personal expression of the city through portraits of its people.

I feel relatively free photographing in Bombay, partly because of my own familiarity with the city, but also because of the openness in the outlook of its people and their acceptance of the camera. This is partly due to the city's film industry, and to the growing sub-culture that has been spawned by television. I have rarely encountered hostility or scepticism while photographing people in their homes or on the streets: access to a stranger's home is possible and often leads to friendship. Recently, while walking around the red light district in the city centre, I photographed a wedding which became the starting point of a friendship with some of the women. Many visits and photographs later, I got to know Saira's family. Though we often met at her home, I never photographed her singing to her customers at night, but preferred instead to do a quiet portrait of her with her best friend Rani and niece Pinky on a porch outside their room on a lazy afternoon.

The tension and pace of a big cosmopolitan city is always interesting. In Bombay there are perpetual public gatherings and street festivities which are interesting visually not only because of what is happening centre-stage, but also because of the more personal moments on the periphery. Take Bombay's most important annual festival, the immersion of the Hindu deities Ganesh and Gauri. At this time the city streets are closed to traffic while millions of people – each carrying their own little statuette or community effigy – flood the city's beaches for the bathing of the Gods. Even here, amongst the most aggressive of crowds there are quieter moments of devotion and distraction as in the photograph of the family of little girls, their mother and Gauri, or the frenzied moment of intensity as a crowd watches a twenty feet high effigy being immersed in the sea.

Resting Place, Dockyard Road
(1989)

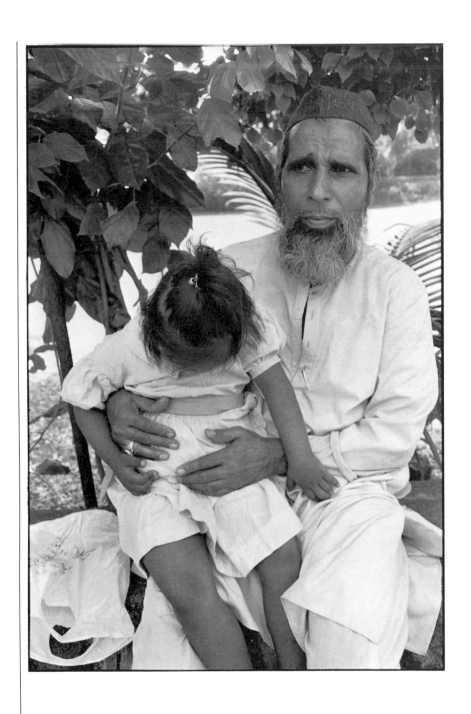

Tasneem and her father,
school for children in need of
special care, Sewri (1989)

Portrait of Falak, Bachubhai Ki
Wadi (1990)

Like the world of the Gauri/Ganesh devotees and revellers, Bombay has a
myriad other worlds that contribute to the city's culture – the world of the
movies; the world of the survivors; the world of different ethnic, religious,
regional and class communities; the private world of homes and the public
world of the streets.

Gauri worship, Chowpatty
Beach (1989)

Gauri devotees, Chowpatty
Beach (1989)

Ketaki Sheth was born in Bombay in 1957. She was educated both in Bombay
and the United Sates where she received a Master's Degree in
Communication Arts. After a brief stint as a journalist with a Bombay
newspaper and magazine, she turned to photography full-time. Her earlier
work was exhibited in *Four Indian Women* at the Horizon Gallery, London
(1988). She is currently working towards a major solo exhibition in Bombay
for early in 1991.

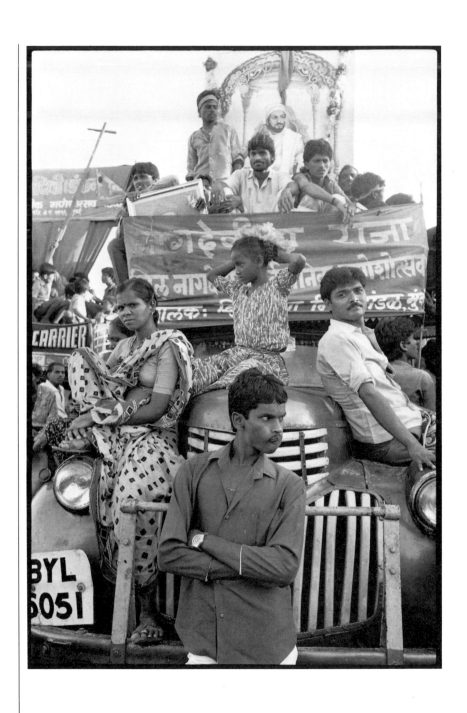

Celebrating Gauri Festival,
Chowpatty Beach (1989)

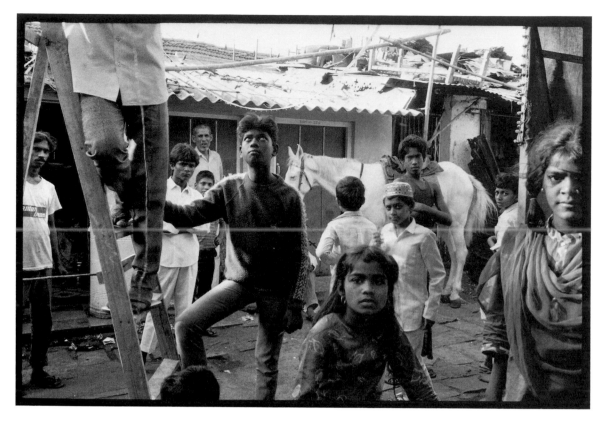

Preparing for the wedding,
Bachubhai Ki Wadi (1990)

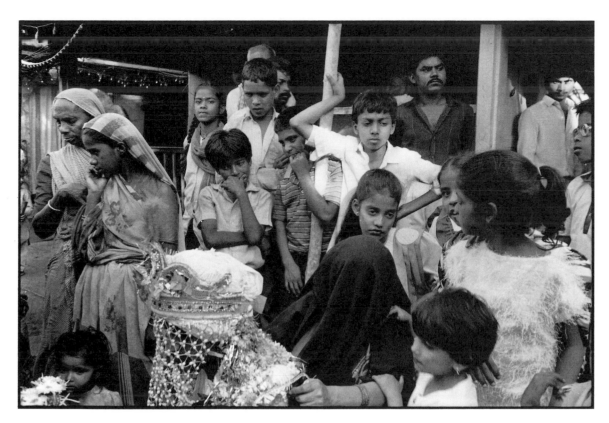

Abid's wedding, Bachubhai Ki
Wadi (1990)

Janabi and Niloufer at home,
Mohammedally Road (1988)

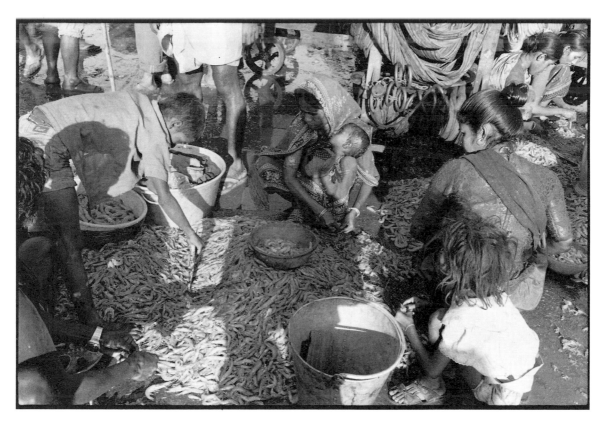

Mother and child, Fishmarket,
Ferry Wharf (1990)

Mother and child, private
wedding reception, Colaba
Agiary (1988)

Movie star rehearsing his lines,
Hotel Juhu Centaur (1987)

> *If you live in a working class area*
> *And think it's unfair, how dare ya*
> *We'll take care of you*
> *And a couple more too*
> *To tell you the truth, we can't bear ya*

Sanjeev Saith

PRAYER FLAGS

*T*he first thing that the Sherpas did on reaching the site for our base camp on Everest was to string up long rows of prayer flags between anchors of ice seracs, rock cairns, and radio antennas. The wave train of primary colours gently rose and fell with every gust of wind, scattering the prayers of each Sherpa over the ice forms of the Khumbu. The Sherpa knew that his own link to life here was as tenuous as the thread that held his prayer flags together. The fragility of his existence in the Himalaya was driven home even further by the pitiful insignificance of his self against the scale of his surroundings. The ground here was wind-carved rock and moving ice, not for man to till; the air was thin, not for man to breathe. This was terrain meant for gods, and mountaineers.

Lives have not remained quite so elemental for the mountain people lower down in the valleys. True, the Lahuli shepherd still sets out each day with his flock to the steep, grassy pastures above the stars and the cold. He follows the drooping tongue of snow over a high pass into another valley where nature is kinder. Such is tradition, beyond the reach of change.

Some may not be able to keep in time. Like the Nepali woman in Ranipul. Long displaced from her home, she bravely preserves an ornamental identity as her road gang tars the highway leading to the urban unease of Gangtok.

I had once watched a wandering monk stopping to rest in the marketplace of the hill capital. He was an old man; his trappings spoke of a lifestyle where an equilibrium had been established between the needs of an ageing body and the demands of an ascetic code. In the minutes that I watched him, he seemed to withdraw from the fuss of the bazaar to some private space, where he perhaps continued to try to find that clear, pure note in the silence.

Two years later I followed a much younger monk – a child – in the same market. His red robes looked quite incongruous as he whiled away the

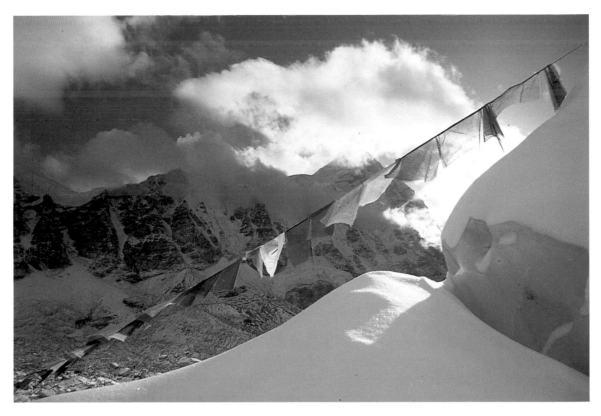

Prayer flags, Tashi Viewpoint,
Sikkim (1990)

evening in the street, watching people go by. One hundred yards away, a young Sikkimese boy reflected his alienation, having walked out of a video parlour, probably bored by the films that he had seen once too often. Below him, a migrant vendor hawked betel leaves and lottery tickets, from his snug recess under a staircase.

Late that night, I drove up to the ridge high above Gangtok to get a clear view of an Himalayan sunrise. As the sky lightened, the characteristic morning breeze began to blow. It came from the peak of Kanchenjunga, now glowing as if lit by an inner flame. I stood between two tall conifers, buffeted by gusts of increasing power. Above me, the prayer flags strained at the branches. In patches of blue, green, yellow, white and red, they billowed toward Gangtok, releasing their prayers on a wing over the sleeping city, still in shadow.

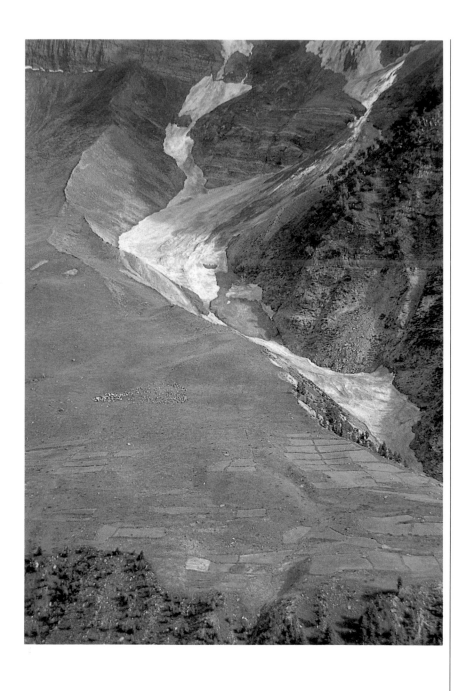

Pastures and mustard field,
Lahul, Himachal Pradesh
(1988)

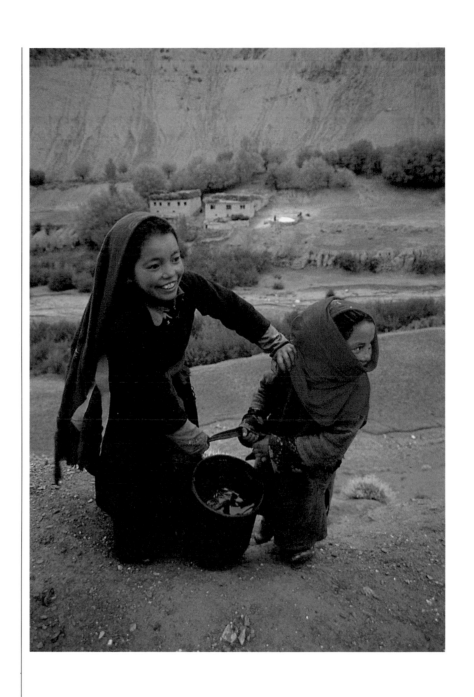

Girls fetching water from river,
Ladakh (1987)

Open-air school, Himachal
Pradesh (1982)

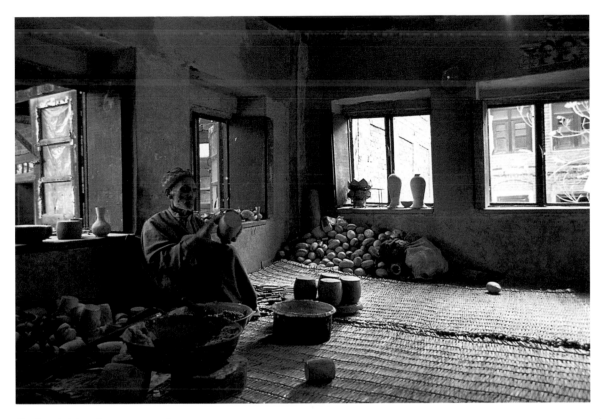

Papiermâché craftsmen at home, Srinagar, Kashmir (1989)

Sanjeev Saith was born in New Delhi in 1958. He studied economics at St Stephen's College, Delhi University and at the Delhi School of Economics. He has since participated in fifteen mountaineering and river-running expeditions spanning the Great Himalayan Range. His career as a photographer emerged from his interest in mountaineering; a compulsion that has evolved into a continuing study of the lifestyle of Himalayan people. Currently he works as a freelance photographer based in New Delhi. Exhibitions: *Savdhan! Bacche Khel Rahe Hain* (Caution! Children at Play) A study of spastic children participating in Remedial Drama, Shriram Centre for Arts and Culture, New Delhi (1984); *Wastelands – Challenge and Response*, co-ordinated and contributed to this exhibition on the development of India's wastelands, Pragati Maidan, New Delhi (1987); *A Journey down the Ganga*, photographs depicting life along the River Ganga from its source in the Himalayas to the Bay of Bengal, Lustre Press, New Delhi (1989); *Legendary Mountains – An Informed History of Four Great Himalayan Peaks*, Oxford University Press, New Delhi (forthcoming).

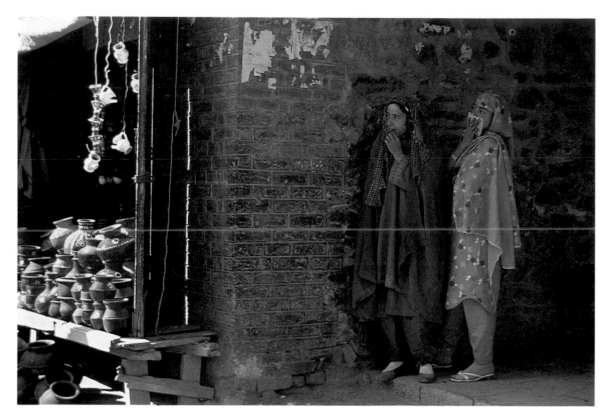

Coloured pots and women in
a shadow, Chari Sharif,
Kashmir (1989)

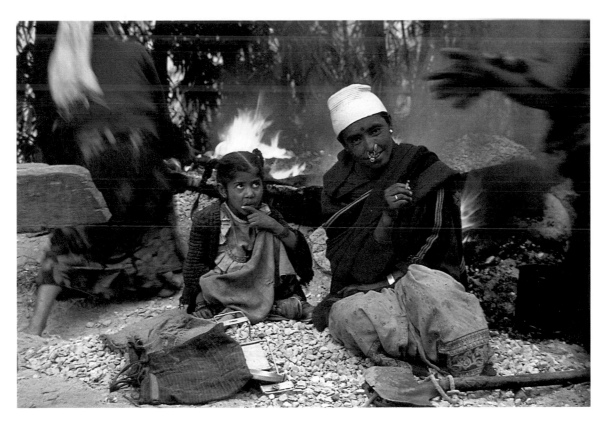

Nepali road gang, Ranipul,
Sikkim (1990)

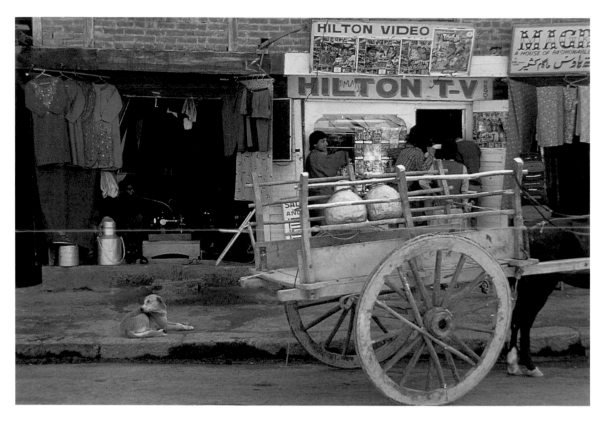

Milkboy and video parlour,
Magam, Kashmir (1989)

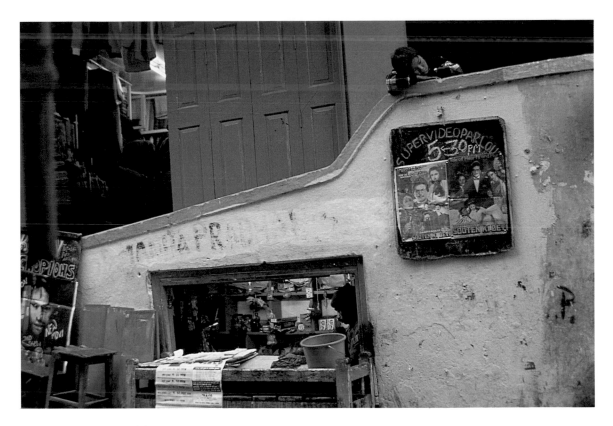

Paan shop with lottery tickets
on sale, Gangtok, Sikkim
(1990)

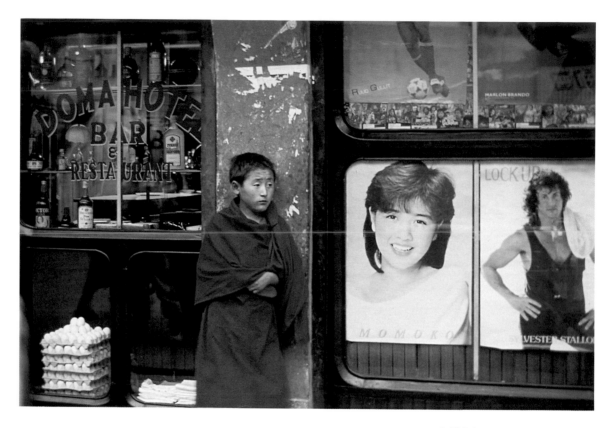

Child monk and bar, Gangtok, Sikkim (1990)

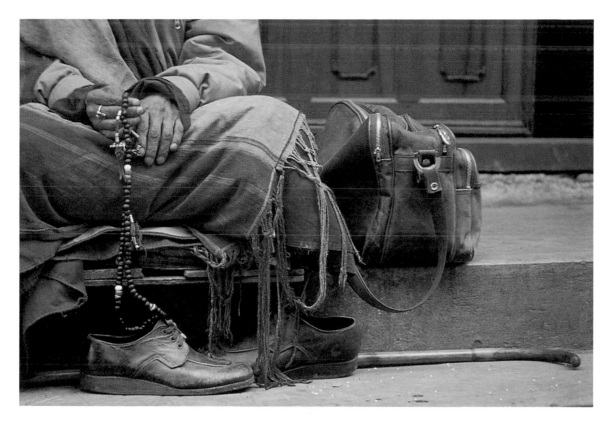

Monk in meditation, Gangtok,
Sikkim (1988)

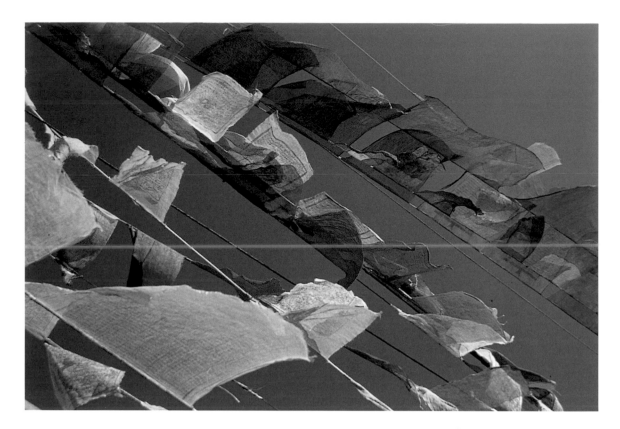

Prayer flags (1990)

You know that today all the buyers
Are shopping for their own messiahs
They're not asking for much
They just want a crutch
To help them cross their own hellfires

Sooni Taraporevala

PARSIS

I was born into a very Parsi family – my parents are first cousins. I attended school in Bombay with girls who were Hindus, Muslims, Jews, Jains, Christians. Communal insults were part of growing up – Parsis were called 'mad bawajis'. In a human biology class we learnt about genes. I went home that day, horrified and asked if they were aware of the risks they took when they conceived me. I could have been born crazy! What if I had been born with a tail? They just laughed and said – well everything worked out well didn't it? I suppose so – but still. . . .

When I was eighteen, I received a scholarship to study abroad. Distance gave me a certain critical perspective and maybe also, a form of nostalgia. When I returned to India, I began to photograph my family, friends and other Parsis; relatives I loved were dying, neighbourhoods were changing. I wanted to document them before they disappeared, in black and white and in colour.

To explain to the viewer who the Parsis are, and what the photographs are about, I requested Adil Jussawalla, a poet and a Parsi himself, to write a brief introduction.

'Parsis, originally refugees to the west coast of India from ninth-century Persia, settled all over the world, but as a community have made their mark chiefly in the city of Bombay. Displaced from Persia by Islam, they are fiercely protective of their religion, which is based on the teachings of Zarathustra, a prophet whose influence spread with the growth of the Sassanian Empire (226–651 AD).

Nevertheless, by neglecting their priesthood and their fire temples, and by allowing no converts, the Parsis of India have caused their community to decline: there were some 110,000 Parsis thirty years ago, and only about 71,000 today. Emigration to Britain, USA and Canada accounts for some of the loss in numbers, but late marriages and a low birth rate are also responsible for the state of the community today. Half-humorously, half-

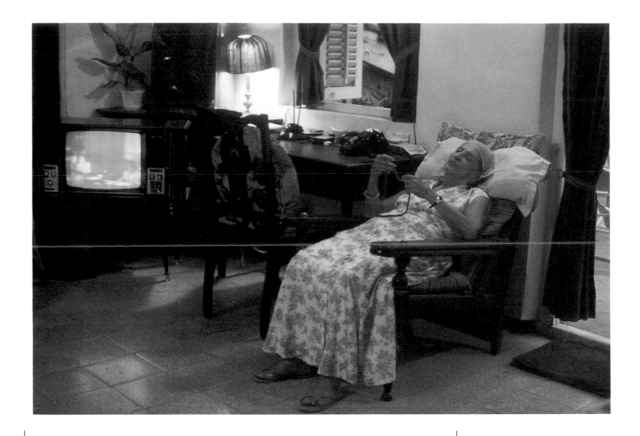

desperately, the Parsis themselves recognise they are an endangered species.

These photographs capture features of a dwindling, self-threatened community, without descending to caricature: a certain middle-class ghettoisation, focussing on 'Irani' restaurants set up by more recent Zoroastrian migrants, where advertisements from British days exist alongside icons of Zarathustra and Christ; a fondness for Western classical music, amounting to near-worship of composers such as Mozart and Beethoven; a novice priest submitting to the ritual of having his head-dress tied – a ritual with little meaning for him and those of his age; and the prayers to sun and sea, since both fire and water are sacred.

Twelve photographs. A small, accurate compass.'

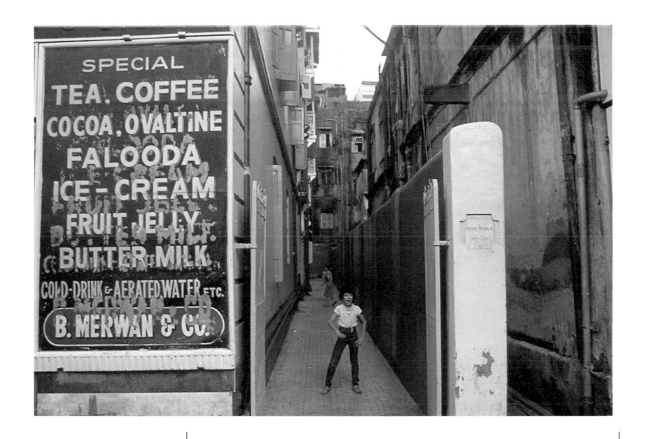

Sooni Taraporevala was born in 1957 in Bombay. From 1975 to 1980 she studied literature and film at Harvard University and learned photography from a friend. After graduate work in cinema studies at New York University, she returned to India in 1982 and worked as a professional photographer for magazines and newspapers. Her photographs have been exhibited in India, USA, France and Britain. Her recent work includes writing film scripts: *Salaam Bombay!*, *Freedom Bird*, *Mississippi Masala* and *This Number Does Not Exist*. She has plans to publish a book of her Parsis photographs sometime in the future.

Adil Jussawalla is author of two books of poems and editor of an anthology of Indian writing.

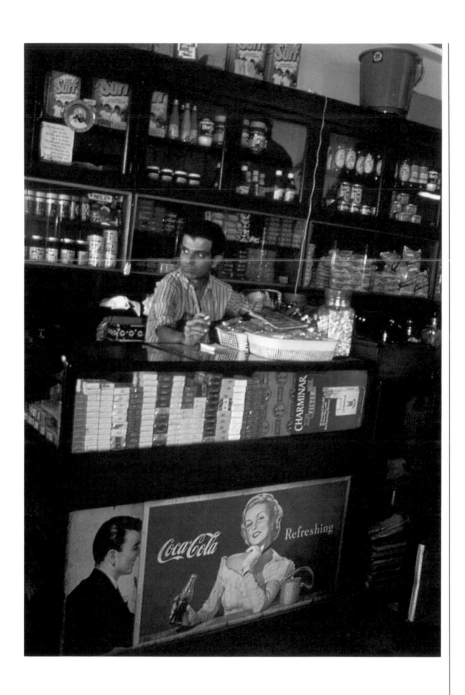

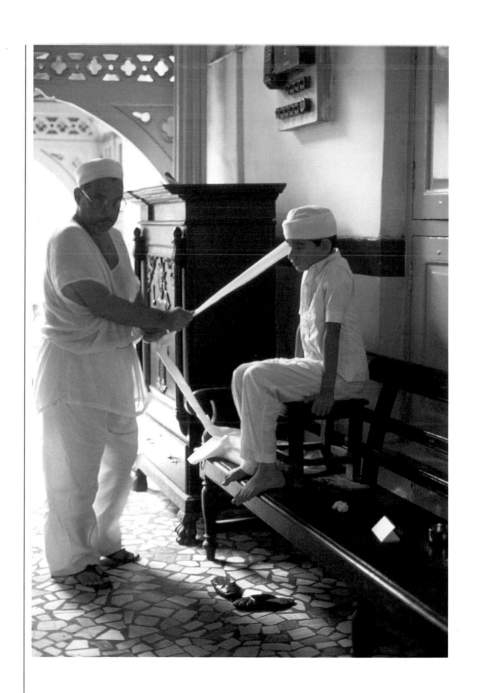

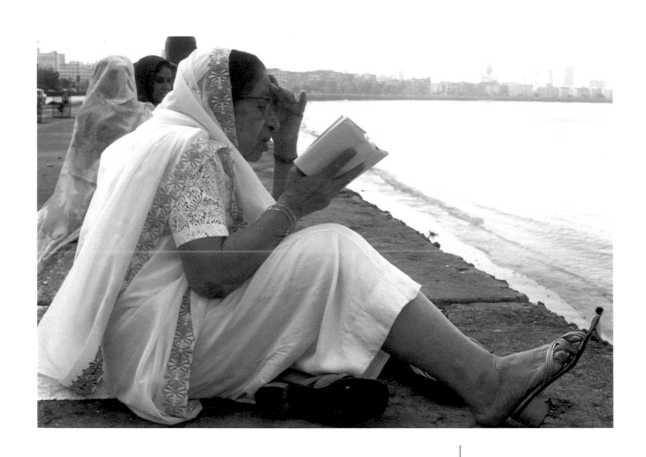

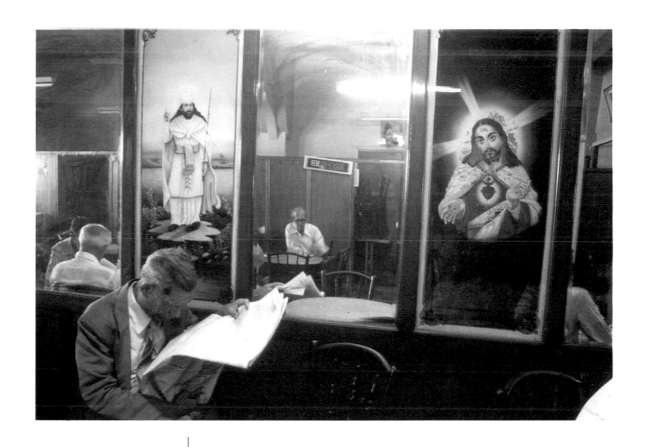

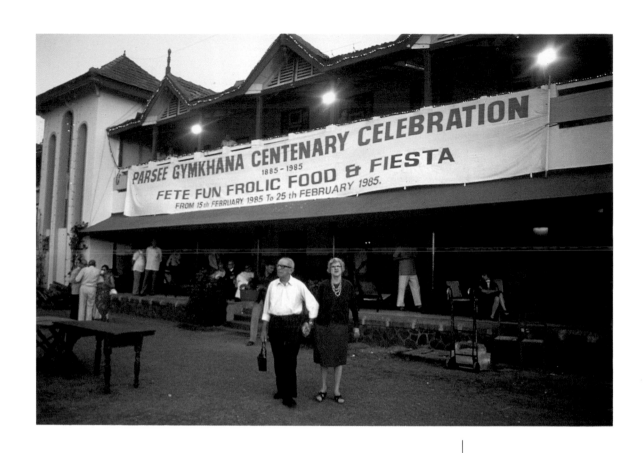

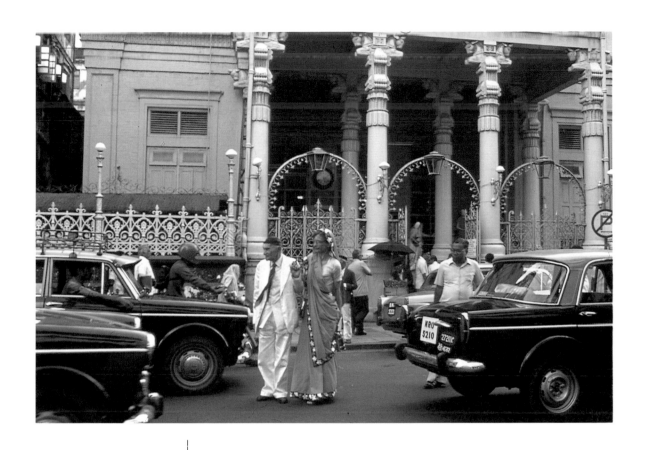

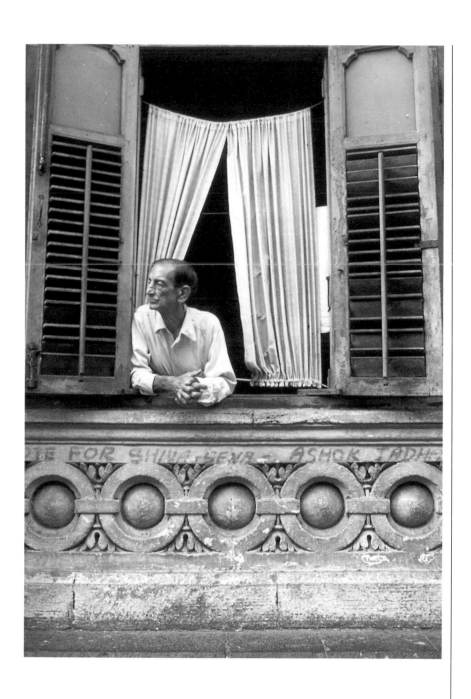

Let's join all our forces together
Air, land and sea so that whether
We win or we lose
It's an excellent ruse
On which our ambitions we tether

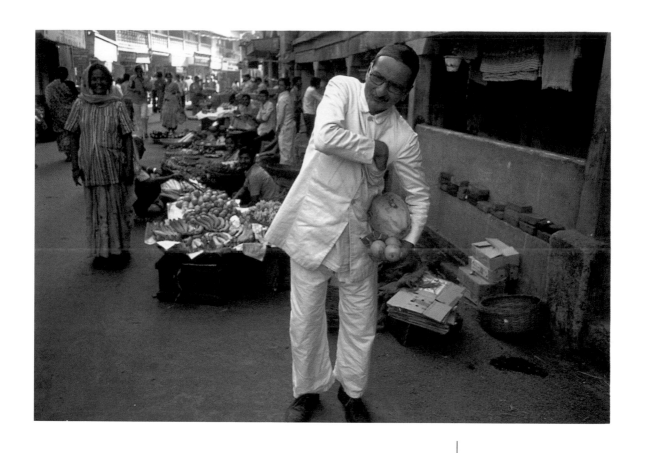

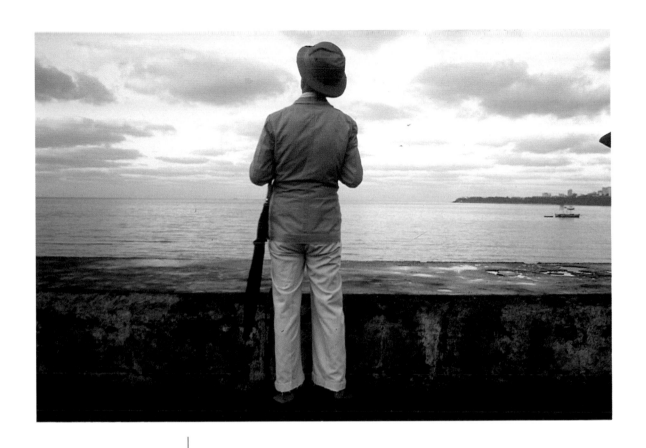

The caste system doesn't exist
All names are on famine works lists
We're moving ahead
More people are fed
And leftovers are clutched in our fist

POSTSCRIPT: Photography in India – an insider's view

Ram Rahman

Photography and cinema both reached India soon after they were invented in Europe. But while cinema was rapidly adopted, Indianised and went on to become a major cultural force, photography has remained a poor cousin. A key reason for this is that under the onslaught of British colonialism in the nineteenth century, traditional patronage to the arts was altered forever. The visual arts were the most badly hit, while the classical and folk performing traditions had a longer survival. Cinema naturally drew on these traditions and transferred some of that vitality to the new medium. Unfortunately the unravelling of the visual arts was so complete that we are still to develop a modern tradition of any vitality or true cultural significance, and in this, photography is many years behind other media in India.

The great traditions in Western photography, particularly in Europe and America, have their roots in the visionary work produced almost immediately after the process became practical in the mid-nineteenth century. In France, inspired by Victor Hugo, photographers documented the rich trove of medieval monuments with funding provided by the government. Similarly, in America photographers ranged out with the colonisation of the West, to document the continent for Congress. Already there was a recognition of the primary power of this new medium, documentation, and an instant realisation of its value as historical record. Remarkably, the images produced by these early practitioners transcended the mundane and carried a poetic power. Being unwieldy, the medium demanded that attention to craft had to be meticulous; the glowing prints from the nineteenth century remain a testimony to those skills.

The early photographers in India were Britons who travelled around the country producing genre views for consumption back home. There was some remarkable work produced. The pictures by Felice Beato of the aftermath of the siege of Lucknow in the First War of Independence in 1857 or that of the dying Mogul emperor, Bahadur Shah Zafar, in exile in Rangoon by P. H. Egerton, contain poignant power and are an unparalleled

historic record. The British and Indian photographers who photographed for either the colonial rulers or Indian royalty did work in almost all the accepted genres of photography: portraits, exotic or travel scenes, landscape and social records. These were mainly collected in the form of albums. Tragically, most of these left the country long ago, and leaves were selling freely in American galleries in the 1970s where the few books on this work were published. These include *The Last Emperor* and *Princely India* by Clark Worswick and later, *Through Indian Eyes* by Judith Mara Gutman. This history is essentially unavailable to us as Indian photographers. It is only after we have critically assimilated and examined that tradition when it will have meaning for us.

In this century we have developed three major streams: the salon or photo-society pictorialism, the commercial and the photojournalist. Of these the pictorial or salon tradition is an anachronism picked up from the post-Victorian British photo societies. This is still widely promoted in India through photo clubs and societies, who compete with each other to produce ever more puerile pictures of sunsets and portraits with superimposed roses, for which they award each other prizes. This tradition, the equivalent of amateur Sunday painting has long been marginalised in the rest of the world, but we continue it with gusto. The commercial work now being produced in India is much more professional and is technically the most refined. This reflects the increasing sophistication of our industrialising consumer economy. Photojournalism is one area where we have had more success. It is the one area where there have been a large number of practitioners whose work is in the public eye.

But even here, we have not really kept up with the vibrancy of the press. The late Kishor Parekh in the 1960s gained recognition for the quality of his work. More recently, Raghu Rai has acquired a level of pop-stardom. Raghubir Singh, with his over twenty-year body of work in colour, has transcended his origins as a photojournalist, bringing a more self-conscious modernity and sophistication to his work, and has become the only Indian to gain critical attention in world-wide photography circles. Yet we have not developed a coherent tradition at all.

One of the primary reasons for this is that we have no means of properly displaying or accessing work, either through publications or exhibitions. There is no way of looking at the extensive document of tribals done by Sunil Janah, for instance, or the old Indian interiors by T.S. Nagarajan or numerous other bodies of work which are bound to exist. Only work done by Western photographers of international stature like Cartier-Bresson is easily available in book form.

India is a rich subject for a photographer. The incredible social change we have undergone in this century, the contrasts that exist in cultures, races, the surreal visual juxtapositions around us, the rituals, political action, all overlaying each other are prime subjects. In fact it is almost too rich, and one has to try and frame an order on the seething chaos.

Sadly we remain like frogs at the bottom of a well, cut off from all the developments and critical advances in the rest of the world. It remains a profession which requires such high capital investment, that only people from the relatively affluent classes can hope to enter it. Most photographers are badly paid by magazines and newspapers, which reproduce their work very badly. Craft has completely plunged, as any comparison with earlier printing and even magazine reproduction, design or typography will show. The Lalit Kala Akademi organised a Biennial of Indian photography which is dominated by the salon pictorialists.

There are few signs of positive developments. The Indira Gandhi National Centre for the Arts in Delhi has acquired a large collection of Cartier-Bresson's Indian work and the archives of Lala Deen Dayal. Finally we will have an institution with resources to hopefully build a collection of work and make these available to a wide public. The first permanent gallery of photography, the Piramal Gallery in Bombay's NCPA, has almost completed a year of functioning. There is also an emerging breed of younger photographers with exposure to the West, particularly American photography, who are beginning to apply some of those lessons over here. Unfortunately, they are being included in more shows outside India, and are gaining some recognition abroad, and have yet to make a mark locally. We will need our institutions to nurture critics and curators with professional training to bring some direction and encouragement to photographers.

It is only through exposure to world-wide movements, developments and history that our photographers will be able to look at their own work with an objective critical eye and to mature. Institutions can also provide funding for extended projects which may seem to have no immediate commercial returns. The body of work produced under the American Farm Security Administration's photography unit in the depression of the 1930s and in particular the work of Walker Evans, is now regarded as one of the highest achievements of all American art. This is cheaply available to the general public through the Library of Congress.

Of all the visual arts, photography has the audience and the potential for becoming a truly major cultural force in India, but it would need a sustained vision to bring it about. It would require an understanding from government institutions, industry, publishers, editors, writers and critics.

Instead of being treated as a merely illustrative medium, to accompany text, it needs to be recognised for its powerful role in its own right. Perhaps then there will be adequate recognition of people like Krishna Murari Kishan, whose pictures of the social-political contemporary milieu in his native Bihar are images with the stamp of truth and a haunting sense of poetic tragedy. No painter has produced images of equal power. This is what photography can do in India, and should do, against all odds.